IMAGES
of America

SENOIA

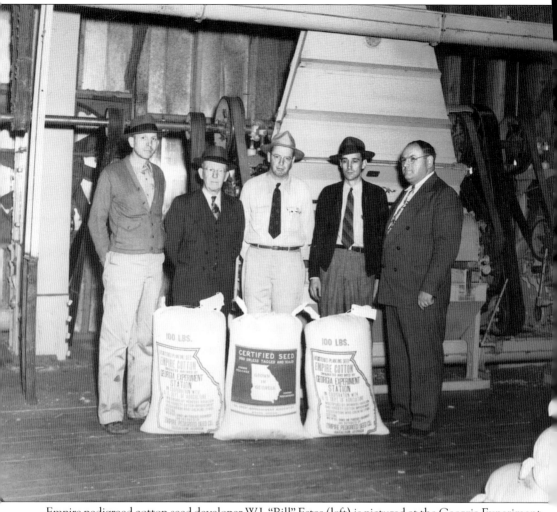

Empire pedigreed cotton seed developer W.J. "Bill" Estes (left) is pictured at the Georgia Experiment Station with, from left to right, Paul McKnight Sr., Coweta County agent Bill Brown, Floy Farr, and Frank Daniel. The experiment station provided Georgia farmers with an agricultural network for over 100 years. About 600 families planted 6,000 acres of Empire seed in Coweta, Fayette, Meriwether, and Spalding Counties as the One Variety Improvement Association, which yielded $773,153 in 1950. (Courtesy of Tray Baggarly.)

ON THE COVER: When Jim Baggarly needed help on his farm in the summer of 1941, neighbors crowned with sun hats worked in the sweltering heat to bring in the harvest. Ida Gill (foreground) picks cotton with her daughters, from left to right, Marie, Farris, and Bett, along with JoAnn Williams, Titia and Mary Drake, Maybell Morgan, and Pearl Freeman. Carl Drake is pictured in the background. (Photograph by Sue (McGhee) Williams; courtesy of Martha Gill.)

IMAGES
of America

SENOIA

Carla Cook Smith
Foreword by Tray Baggarly

ARCADIA
PUBLISHING

Copyright © 2019 by Carla Cook Smith
ISBN 978-1-4671-0550-7

Published by Arcadia Publishing
Charleston, South Carolina

Printed in the United States of America

Library of Congress Control Number: 2020935622

For all general information, please contact Arcadia Publishing:
Telephone 843-853-2070
Fax 843-853-0044
E-mail sales@arcadiapublishing.com
For customer service and orders:
Toll-Free 1-888-313-2665

Visit us on the Internet at www.arcadiapublishing.com

*This book is dedicated to Jim Baggarly Sr.,
Walter Baggarly, and Melvin Cheek, who each made
significant contributions to preserve Senoia's rich history.*

Contents

FOREWORD

Senoia's motto is "The perfect setting. For life."

I am the fifth generation of my family to call Senoia home, my children being the sixth. This book pays homage to a once-small town, rich in history and heritage with the feel of family, neighbors, and people caring for people. All my life, I have heard numerous stories about how the people of Senoia looked out for one another, lent a helping hand, and most importantly, loved one another.

Twenty-five years ago, I joined lifelong Senoia brothers Randy and Bill Todd in establishing the *Coweta Journal*, also known as the *Senoia Home News*. Together, we worked hard to provide our residents with weekly stories about the community, and those were the best years of my newspaper career. We reported current events and mixed in stories of Senoia's history as well. I learned a lot about the town where I was raised and grew to anticipate its exciting future. The future is here, and to embrace Senoia's history today is of the utmost importance.

Change is continuous as Senoia grows and prospers. Not everyone appreciates change, but it is something that is inevitable. I do not know everyone in town like I once did, and I cannot let my six-year-old walk to town alone donning cowboy boots and a hat like my dad did in 1939, but Senoia is still my home, the home of my children, and the ancestral home of the Baggarly family going back to the founding of Senoia by my great-great-grandfather, Rev. Francis Warren Baggarly, in 1860.

It is my hope that lifelong Senoia residents and newcomers alike will enjoy the story Carla (Cook) Smith shares in the following pages and that readers will come away with a good understanding of how Senoia began with hardworking individuals, how it has progressed to where it is today, and that the people of Senoia are still helping people and caring for each other just like God intended. Senoia remains the perfect setting for life.

—Tray Baggarly
Director, Coweta County Event Services
Editor of the *Coweta Journal*

ACKNOWLEDGMENTS

I am grateful to everyone who has had a hand in helping my effort to preserve Senoia's rich history in this book. Senoia is very fortunate that Jim Baggarly Sr., his son Walter Baggarly, and Melvin Cheek each had the foresight to preserve parts of Senoia history for future generations. Thank-you to Janet and Scott Baggarly of the Senoia Buggy Shop Museum; Jim Baggarly Jr.'s son Tray Baggarly; Sue (Adams) McDaniel; Barbara (McDaniel) Ray; Olin McDaniel Jr.; Jane (Hutchinson) Arnold; Geoff, Karen, and Angela (Banks) Tinsley; Brenda and Gary Welden; Randy, Bill, and Brantly Todd; James "Jim" Barnette Sr.; Reuben and Sue Welden; Kathryn "Callie" Welden; Cynthia (Williams) Christopher; Fayette County historian John Lynch; Bobby Kerlin and Tony Parrott; Martha Gill; Marla (Gill) Dugan; Hal and Vicki Sewell; Betty (Cookman) Armstrong; Eleanor Cooper; Totsie (Carrasco) McKnight; Carl McKnight Jr.; Ellis and Patricia (Yarborough) Crook; William Tinsley; Bill Tinsley; Peggy (Tinsley) Hall; Patsy Tinsley; Natalie (Tinsley) Mrozek; Joyce (Cleveland) Smith; Vicki Pollard; the Pollard family; JoAnne Utt; Ronnie and Susan (Robinson) Whatley; Jo and Leigh Morgan; Frank and Bill Harris; Maureen Schuyler (opening museum for me to scan racetrack photographs with permission from Vickie Pollard); Lynn Horton; Frances Pollard; Bonne and Frank Hollberg; Mary Ann and Butch Reese; Cindy Divido; Billy Arnall; Dodie (Smith) Hamrick; Aimee Duke; Mary (Nell) Childs; Martha (Bishop) Lamber; Connie (Bishop) Sharp; Linda (Bishop) Sutherland; Roy and Jerry Bishop; Libby Bedenbaugh; Gail Downs; Ann and Jack Merrick; Suzanne Helfman; James Ray; Vickie McGuigan; John Tidwell; Al Franklin; Scott Carter and New Tech Photo; Wanda (Glazier) Jones; Leta "Lee" Joyner; Vernon and Beverly Bishop; Jeff Bishop (Boy Scout photographs and referral to Robert Wilkerson); Bobbie Montgomery; Blake Adcock; Judy Mullis; Annie (Maynard) Alexander; Dianne (Pollard) Adcock; Nancy Roy; Rick Minter; Bill Massey; Marcie (Bristol) Sims; Doug and Lori Kolbenschlag; Senoia mayor Dub Pearson; Rick Reynolds; David and Suzanne Pengelly; Robert Wilkerson; Mark Puckett; Shirley Orr; Nancy Tinsley; Clara (Garrar) Treadway; artists Melissa (Dieckmann) Overton and Nancy (Snyder) McConeghy; my husband, Clint Smith; my friend Deborah (Moore) Dieckmann; and last but by no means least, Katelyn Jenkins, Caitrin Cunningham, and Ryan Vied of Arcadia Publishing.

INTRODUCTION

The Koweta band of the Creek/Muscogee Indians settled near bodies of water (thus, the "Creek" moniker) in Georgia's piedmont in the area that became Coweta County about 400 BC. Creeks referred to themselves as Muscogee (Mvskoke), which included Koweta, Cusseta, Yuchi, Coosa, Tuskegee, and Koasati, who spoke the Muscogee language.

JoAnne Utt related that Senoia is likely named after Koweta Creek Indian maiden Senoyah, whose father was a *heniha* (high-ranking designation/Wind Clan). According to Utt, Capt. William McIntosh met and married Senoyah while on assignment at a fort near her home. Senoyah bore him two sons, and when her husband left for Scotland, he took the boys with him. Senoyah's brothers stole aboard his ship and retrieved their nephews (one was William McIntosh Jr.).

A mid-1700 colony map shows the capital of Koweta Creek territory on the Chattahoochee River near McIntosh Reserve in Whitesburg. Additional settlements are noted along the river northwest of Newnan on the present-day site of Chattahoochee Bend State Park and in Indian Springs. Lower Creek Indians from Alabama rose up against European culture and fought West Georgia Creeks and the US military in the Red Stick War (1813–1814). The expression "Lord willing, and the Creek don't rise" has nothing to do with water but reflects raging tempers, which led to war. Creeks serving the US military returned home to find family dead and homes destroyed by order of Gen. Andrew Jackson, and many fled in 1817.

The Creek Nation was governed by mutual agreement, meaning that a high-ranking officer did not have the authority to make an independent decision. The *mekko*, heniha, medicine man, and other high-ranking officials formed the National Council and made general rulings for their people. The term "Indian chief" is an English expression.

Designated a mekko, Brig. Gen. William McIntosh ceded land to the United States in 1821 via the first Treaty of Indian Springs. Lower Creeks warned of deadly consequences if more Creek land was given away. McIntosh ignored the warning and signed the second Treaty of Indian Springs in 1825, which ceded all remaining Creek lands in Georgia. Enraged, Alabama Creeks swarmed the McIntosh plantation, murdering William McIntosh and his family members as they exited their burning house. Historical documents note that two of McIntosh's wives, some of his children (including his son Chilly), and approximately 200 Creeks took refuge at the plantation of Gen. Alexander Ware located on the Fayette County side of Line Creek (site of a nature preserve).

Fayette County historian John Lynch shared a May 3, 1825, letter sent to Indian Affairs from McIntosh's wives, Peggy and Suzanna. The letter states, "I hope so soon as you read this you will lay it before the governor and the president that they may know our miserable condition and afford us relief as soon as possible." McIntosh's daughter Jane Hawkins wrote a letter to Indian Affairs on the same day, in which she relates, "These murderers are the same hostiles who treated the whites ten years ago as they have now treated my husband and father, who say they are determined to kill all who had any hand in selling the land."

McIntosh built Fort Troup purportedly two and a half miles north of Senoia on the McIntosh Trail on a hill overlooking a creek. The fort was built in case of a Creek uprising. Fort remains could still be seen until 1917, although it is not listed in the *Forts of Georgia* book. The 95-mile McIntosh Trail routes through Georgia, traveling through downtown Senoia, Sharpsburg, and Newnan through Coweta, and on through Butts, Carrollton, Fayette, and Spalding Counties to Indian Springs.

Some remember William McIntosh as a military leader who used Creek land to perpetuate peace. Many Creeks intermarried with their neighbors. Thus, Georgia governor George Troup

was McIntosh's cousin. The governor planned to remove Indians from Georgia by 1825, and some believe that the Treaty of Indian Springs was McIntosh's attempt to appease his cousin so that the Indians could remain. Others believe McIntosh used treaties for personal gain and was a traitor to his Native American people. Koweta Creeks had a history of good relations with white settlers for over a century.

The Creek Indians were gone from Georgia by 1827, and the state held a land lottery to distribute their land. The lottery drew numerous settlers, a large portion of which came from Newberry County, South Carolina, which included the Morgan, Leavell, Summers, Atkinson, Addy, Page, Young, Shell, Moses, Barnes, and Fall families, whose descendants still reside in Senoia.

In 1833, the Central Railroad and Canal Company (CRCC) of Georgia began constructing a railroad from Savannah to Macon. Approximately 190 miles of railway lines were completed by 1834, which made CRCC the longest, privately owned railroad in the world. By the mid-1840s, Senoia's first railroad agent, Thomas Newton Vining, would begin his career with the railroad as a track hand.

A post office was established a couple of miles north of present-day Senoia, and the first settlement in the area, known as Location, grew up around it. Willow Dell was established two miles south in the 1850s on the 202.5-acre tract of land noted as District 1, Land Lot 279 received in the land lottery by Gerrard M. Veal.

Rev. Francis Warren Baggarly arrived in the southeastern part of Coweta County, Georgia, in 1860 on the brink of the War between the States. At that time, he purchased the Willow Dell settlement, later renaming it Senoia (pronounced by locals as "Sinoy.") Reverend Baggarly's ancestors have been traced back to 1066. Lord John Baggarly of Normandy was a cousin to William the Conqueror. John B. Baggarly came to America in 1748 with seven sons and three daughters. His son David became a large landowner in the District of Columbia and donated 333 acres of land to his country (present-day site of the US Capitol and federal buildings). David's son Henry was the father of Reverend Baggarly.

John O. Jones (great-grandfather of Mary Brantly Todd) served at the First Battle of Manassas on July 21, 1861. Capt. William David Linch is recorded as serving the Confederacy at Gettysburg, Chickamauga, and Knoxville. He was with his unit on the November/December roll in 1864 and surrendered with them at Appomattox, Virginia, on April 9, 1865. The captain's brother, Elijah Linch, was the maternal great-grandfather of Al Franklin, who has been a great resource for historical information about the Linch family's service to the Confederacy. Elijah initially fought as a horse soldier in the Confederate calvary. He was transferred to the Navy in 1864 via a special order signed by Gen. Robert E. Lee. Elijah ran blockades on the CSS *Patrick Henry*, a side-wheel merchant steamer originally known as the *Yorktown*. The vessel was chosen as a school ship for young officers in 1863 and sometimes took part in action with students on board. A few months after Elijah joined the crew in 1864, the CSS *Patrick Henry* was set on fire after Richmond was evacuated. Following the destruction of the ship, Confederate cadets guarded the ship's cargo of $500,000 in gold, of which they were each given $40 to aid in their return home.

Former Southern Railroad treasurer Thomas Newton Vining is recorded as serving as a deacon for the First Baptist Church of Senoia, which was organized in July 1867. Vining moved from Macon to help with the railway extension from Griffin to Senoia after the War between the States and stayed on to serve as Central of Georgia's first railroad agent.

The Macon & Western operated part of the railway line completed to Newnan in 1870, at which time it was taken over by the Savannah, Griffin & North Alabama (SGNA) Railroad Company. The SGNA railroad approached Reverend Baggarly that same year about developing a grid for city streets in exchange for property to run rails on an east/west line through Senoia from Experiment (located near Griffin). By 1890, the Savannah & Western Railroad Company acquired SGNA and later became part of the Central of Georgia Railway System.

Senoia's *Enterprise Gazette* was first published in 1891. The popular weekly newspaper was purchased by Lewis Perdue in 1894, and he ran the paper until he sold it in 1899. Ben Nolan later purchased the newspaper, which he edited and printed for over 20 years in a small, wooden building at the back of his Main Street store near Travis Street.

C.F. Hollberg Sr. moved from Ohio to work for Banta Jewelers in Newnan, covering four counties doing watch repair. He moved to Senoia in 1894 at the age of 20, where he set up a watch stand, eventually building a general store and Senoia's first place of lodging. Hollberg was instrumental in having the Atlantic, Birmingham & Atlantic (AB&A) Railway routed through Senoia. When it was reincorporated as the Atlantic Birmingham Coastline (ABC, sometimes referred to as the "Alphabet Railway") by the Atlantic Coast Line in 1926, its service included two express trains that ran from Chicago to Miami daily. In 1947, the ABC line was purchased by the Atlantic Coast Line (ACL), and it became the ACL Western Division. By 1967, ACL merged with Seaboard Air Line to become Seaboard Coast Line. The CSX rail system evolved from mergers (1980–1987), which included the Chessie System—Baltimore & Ohio (B&O) and Chesapeake & Ohio (C&O)—as well as the Louisville & Nashville (L&N) Railroad from the Seaboard system. CSX trains still run through Senoia today.

The War between the States was over, and Senoia was in high cotton when the first set of Walter and Warren Baggarly twins were born to the Reverend and Julia Bowles Baggarly in 1865. In 1890, the twins established the Baggarly Brothers Buggy Shop on Main Street.

Cotton was still king in 1898, and while Senoia was planted deep in white gold, the city's most successful business was a horse collar factory. William H. Langford was the original manufacturer of Langford collars in Senoia. The Couch brothers later set up a factory that produced 200 horse collars per day in its first year, shipping collars throughout the nation and proudly noting the US government as a customer.

Scott Baggarly reports that the Senoia Buggy Shop building housed a cannery in the basement where families would bring vegetables from their garden to put in jars before 1912 when a Coca-Cola bottling operation took over downstairs. Baggarly notes that at one time, Coca-Cola had a bottling plant about every 15 miles, which kept up with inventory and cut down on deliveries to south Atlanta.

Senoia was a thriving city in 1912, at which time it had three churches, a college of telegraphy, five fraternal orders, a hotel, a coal company, two state banks, one national bank, one oil mill, one fertilizer plant, an overall and back band manufacturing company, several lumberyards, a livery stable, twenty-five retail shops, a newspaper, a bottling works, a cement tile plant, two warehouses, and a nice city park; it purportedly also had the best water in the area as well as local and long-distance telephone service. At that time, the city's population was 1,500.

In 1913, Arry Lee Crook opened a small grocery store on Highway 16 in the area where Bank of the Ozarks is located today. Arry Lee's eldest son, Julian, came up with the slogan: "Get an Honest Deal from a Crook," which is still printed on grocery bags at Crook's Marketplace.

Founded in 1925, Southern Mills has five facilities in Georgia, two of which are in Senoia. Over the years, Southern Mills has supported civic, church, and city programs, helping Senoia grow in a positive direction. Known today as Tencate Southern Mills, Inc., the company manufactures nonwoven, fire-protective fabrics. Numerous Senoia residents worked at the mill. Parker Cleveland began work there in high school and eventually became vice president of sales. Martha Gill worked as a bookkeeper for many years. Frank Harris worked briefly for 75¢ an hour as a weaver. Joyce (Cleveland) Smith had a 30-year career at the mill, retiring as its corporate purchasing manager.

Following Walter Baggarly's death (1931), the buggy shop closed. Jim Baggarly Sr. opened it to the community as a gymnasium in the 1940s. "There were no paved roads, only dirt, in Senoia at that time," Janet Baggarly relates. "There was simply no place for the children to play without getting extremely dirty. I believe my mother-in-law, Rubye Baggarly, probably encouraged the use of the gym as it must have cut down on the dirt her three young children (Jim Jr., Walter, and Warren) traipsed through her antebellum home on Baggarly Way. Mr. Jim Sr. installed basketball hoops, and the children of Senoia had a wonderful time together at the gym."

In 1939, Jim Baggarly Sr. was hired to work an 82-mile postal route that ran over dirt roads through Coweta and Fayette Counties. For 36 years, the beloved postal carrier drove a Model A Ford (which routinely got stuck in the red clay mud) on his mail route. (Jim's grandfather, Rev. Francis Warren Baggarly, is recorded as being the postmaster in Warnerville [Meriwether County]

in 1854, and his aunt Alice (Chatfield) Baggarly served as postmaster for Senoia in 1893 and was reappointed in 1901. Alice was also the US register of civil, military, and naval services. (Senoia resident and former city clerk Betty (Cookman) Armstrong provided this information.)

Music filled the buggy shop building on weekends in the 1940s. Joyce (Cleveland) Smith and Sue (Welden) Williams remember large crowds spilling onto Main Street to dance. Smith recalls, "Sometimes, the Senoia Band performed, and sometimes, we played the Nickelodeon (a jukebox that played a song for a nickel)." Williams remembers listening to Perry Como and Eddy Arnold in those days. "Mr. Hunnicutt sometimes played the guitar for us to dance by. Men and boys went off to war, and the dances eventually stopped."

Kathleen and Paul McKnight owned a dry goods store downtown from the 1940s until 1963 (also the site of Gail's Antiques from 2002 to 2019). The McKnights sold dry goods, meat, vegetables, potatoes, and cloth. Daisy Harris (mother of Frank) ran the clothing department, and Claude Johnson managed the store. Connie (Bishop) Sharp recalls entering the store from the alley and walking past large weighing scales at the back of the store on the way to the penny candy. "We would give Mrs. Harris 10¢, and she would load us up on candy." Sharp relates.

Arry Lee and Leola Addy Crook's youngest son, Ellis, began running the family grocery business in 1950 when his father was bedridden for two years with tuberculosis. An enterprising young man, Ellis added air-conditioning to the store in his father's absence, making Crook's store the first business in Senoia to offer refreshing, cool air on hot summer days. Arry Lee recovered from tuberculosis, and he and Ellis ran the grocery store together. Eighty-nine years young today, Ellis enjoys working in Senoia's oldest grocery store, Crook's Marketplace, with his son Greg.

East Coweta High School was constructed in 1954, and a swimming pool was added to Senoia Area State Park in 1958 on land donated by the American Legion Post No. 174 for a park, picnic pavilion, and pool.

In 1960, Jimmy Hutchinson became Georgia's youngest mayor at the age of 25. Senoia mayor Freeman Sasser died of a heart attack shortly after Hutchinson returned to his hometown to take over Hutchinson Hardware following the sudden death of his father. Hutchinson made many improvements, including the acquisition of a new fire truck and helping bring the Synthetic Division of Southern Mills to Senoia.

Senoia's Teen Club was established in the 1960s, providing good, clean fun for local youth. Mary (Nell) Childs relates, "We used to spend all day in curlers and then rock out in the evening at Teen Club." Hal Sewell's band sometimes played at the club.

Senoia Raceway opened in 1969 after Hence Pollard built a dirt racetrack in the pasture of the family farm behind his house. David Bishop partnered with Pollard in the venture, and Pollard's wife, Reba (Whitlock) Pollard, ran the concession stand.

The late 1970s brought about the establishment of the McIntosh Arts and Crafts Country Fair and the Senoia Area Library. Paul McKnight's daughter Alice (McKnight) Ramsey was chosen to carry the torch through Senoia when Atlanta hosted the Olympics in 1986.

When Riverwood Studios came to Senoia in 1989, Georgia was ranked third in movie production behind New York and Los Angeles. The father/son team of Joe and Paul Lombardi purchased land for the studio, appreciating Senoia's close proximity to the airport and its diverse appearance for filming. Later known as Raleigh Studios Atlanta, the studio continued to use Senoia as a backdrop for film and television productions, including *Drop Dead Diva*, *Fried Green Tomatoes*, *Meet the Browns*, and more. AMC enjoyed a seven-year relationship with Raleigh Studios Atlanta for its popular television series *The Walking Dead* before purchasing the 120-acre studio in 2017.

When tourism began to peak in Senoia, Carla (Cook) Smith obtained the first business license for a tour business in the city. Her company, Tour Senoia, brought busloads of tourists to town who learned about Senoia's rich history and saw the sites where numerous movies have been filmed. The Georgia Tour Company was the first to offer a Main Street storefront, film-based tourism, and food tours. Riverwood Studios offered the first trolley tours, and Senoia Golf Cart Tours was the first to offer tours on golf carts.

Following his purchase of the Willow Dell settlement in 1860, Rev. Francis Warren Baggarly established Senoia Methodist Episcopal Church South and began ministering to the community. At the onset of the War between the States in 1861, Reverend Baggarly set up a hat and boot factory in his home, where he employed the wives and children of Confederate soldiers. (Courtesy of Janet Baggarly.)

One

ESTABLISHING AND BUILDING SENOIA

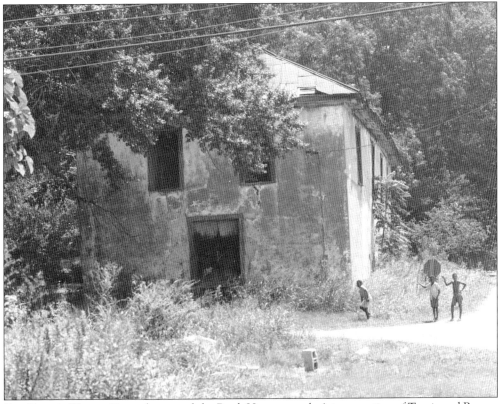

Rev. Francis Warren Baggarly erected the Rock House at today's intersection of Travis and Barnes Streets, holding church services upstairs. The downstairs was initially a mercantile but became a commissary for the Confederacy when war broke out soon after its completion in 1861. Depicted in the 1940s, three young boys play around the stop sign in front of Senoia's first building. Sadly, efforts to identify them have been unsuccessful. (Courtesy of Barbara (McDaniel) Ray.)

Sue (Welden) Williams is depicted in the alley next to the Rock House in the late 1940s. In the distance behind her is the Central of Georgia Railroad Depot. James Barnette Sr. remembers playing inside the depot, where Southern Mills stored its paper. Friends Bobby Shell, Hoyt Smith, Allen Arnold, and Jim Baggarly Jr. joined Barnette in the fun. (Courtesy of Sue (Welden) Williams.)

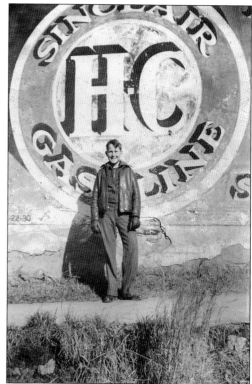

Herschel Couch stands at the side of Senoia's first structure, the Rock House, in front of a Sinclair gas advertisement in the mid-1940s. (Courtesy of Sue (Welden) Williams.)

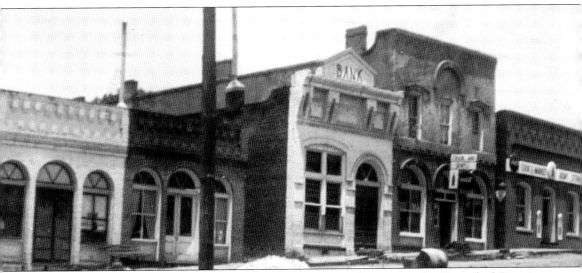

Farmers and Merchants Bank was located on South Main Street near the Central of Georgia Railroad Depot for 87 years. Established in 1874, it was Coweta County's oldest operational bank for 100-plus years. Senoia's population was 1,200 when local businessmen, including Dr. Franklin M. Brantly, Matthew H. Couch (president, 1903–1915), Solomon T. Bridges, John P. Atkinson, William C. Barnes, Calvin J. Fall, Jared E. Stalling, and Thomas A. Barnes petitioned the Georgia Legislature for a bank. W.S. Witham served as its first president (1897–1903). The original vault remained in the building and served as Jeremy Harwell's office when Harwell Photography Studio was housed there. Hugh Crook and Ray Sewell went into business as Crook and Sewell (right of the bank) in 1946. When Crook began his career with the Senoia Post Office, Ray and Edith Sewell opened R.S. Sewell General Merchandise in the same location. Tom and Laura Cook owned the first Cook grocery store on Main Street. Their eldest son, Howell, opened the Cook grocery and army store pictured here. This image is from 1949. (Photograph by Jim Baggarly Sr.; courtesy of Tray Baggarly.)

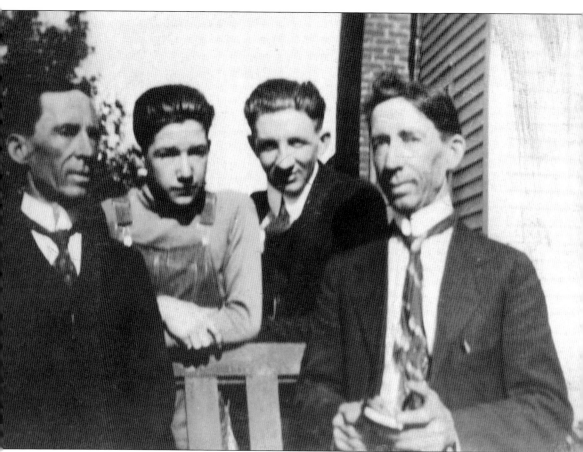

Lillian "Lillie" (Baggarly) Laws was the first Baggarly child born in Senoia (in 1862). Her brothers Walter and Warren were reportedly twins born in 1865 (noted in family documents); however, graves in the Senoia City Cemetery show Warren born two years after Walter. This 1919 photograph shows the brothers in their mid-50s, and Walter (far left) does appear older than Warren (far right). From left to right are Walter Branham Baggarly Sr. (born in 1865) and his only living child, James Harrison "Jim" Baggarly Sr. (born in 1905), Arthur Olin Baggarly (born in 1881), and Warren Francis Baggarly (headstone marked 1867). The brothers established a buggy shop business on Main Street in 1890 (Baggarly Brothers Buggy Shop), which provided wagons, buggies, horse collars, equipment for mules, and automobile accessories in addition to wagon-wheel repair. The business stayed afloat, selling gasoline, organs, and pianos when automobiles slowed the buggy business. Walter bought out Warren's interest in the business in 1905. Today, the building houses the Senoia Buggy Shop Museum, which is chock-full of historical treasures, including Senoia's first gas pump from 1907. (Courtesy of Scott Baggarly.)

Jim Baggarly was the fourth and only child of Walter and May Baggarly who lived beyond 25 months of age. He married Rubye Rives in 1932, and they had three boys: Jim Jr., Walter, and Warren. Known by his grandchildren as "Baba," Jim never had a music lesson but could "tear up a piano," playing hymns, jazz, blues, and rock and roll. A devoted Christian and an active member of Senoia United Methodist Church, Jim established the Played Out Boys Club on the site of the Baggarly Brothers Buggy Shop next door to city hall on Main Street. Members met daily in front of the shop. Jim worked an 82-mile postal route over dirt roads in Coweta and Fayette Counties for many years and was forced into retirement at the age of 70. On his last day, he placed a ruler in every mailbox on his route that read, "It's a government rule—so I must retire at age 70." Jim's ruler and his Model A truck are displayed at the Senoia Buggy Shop Museum. (Courtesy of Janet Baggarly.)

According to C.F. Hollberg Sr.'s grandson, C.F. Hollberg III (popularly known as "Buddy" before his father died and Frank thereafter), "Pops was the only Yankee and the only Jew in town for many years. Ironically, he and my grandmother hosted the annual Confederate Soldiers Reunion at the Hollberg Hotel." (Artwork by Nancy McConeghy.)

In 1906, C.F. Hollberg Sr. constructed the Hollberg Hotel, picking up salesmen from the train and transporting them to his establishment when they came to call on Senoia's flourishing businesses. In 1986, Jan and Bobby Boals purchased the hotel and renamed it the Veranda Bed and Breakfast Inn. Rev. Rick Reynolds and his wife, Laura, fulfilled a dream when they purchased the Veranda in January 2005. This photograph of the Hollberg Hotel was taken in 1910. (Courtesy of the Senoia Buggy Shop Museum.)

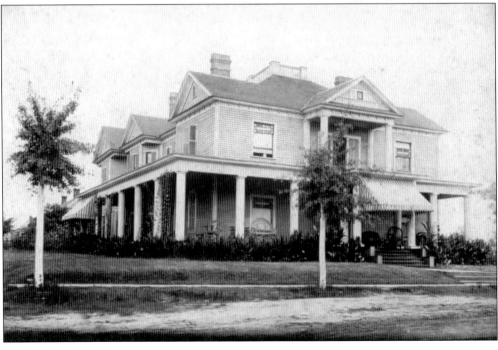

In 1914, C.F. Hollberg Sr. began selling furniture, which included the county's first Atwater Kent radio sets, and became the county's first appliance dealer in the 1920s. C.F. Hollberg Jr. joined his father in the business in the 1930s. Teenager Lucy Tinsley stands in front of the Hollberg's store in the early 1940s. The daughter of Dock Tinsley, Lucy was sister to Kathryn, William, Roy, Patsy, and Jerry. (Courtesy of Gary Welden.)

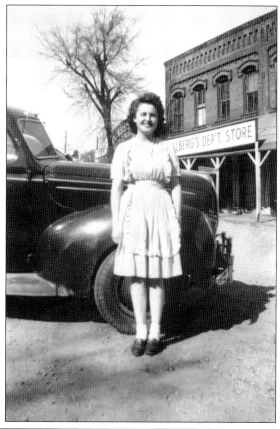

Good friends Totsie Carrasco (left) and Lucy Tinsley (right) visit Main Street together in the early 1940s. Upon closer inspection, Hollberg's Drug Store is visible behind the high school girls, and the old post office is to their immediate right. Totsie's parents were Joe and Alice (Moses) Carrasco, who owned Lake Raymond, a popular recreational site for Coweta County residents. (Courtesy of Gary and Brenda Welden.)

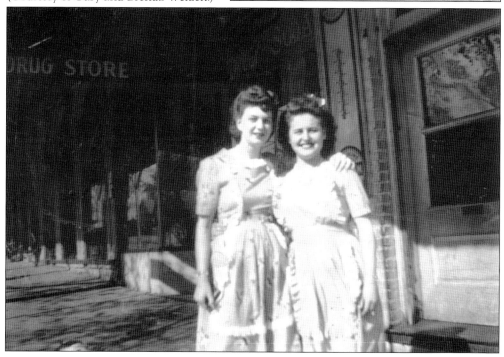

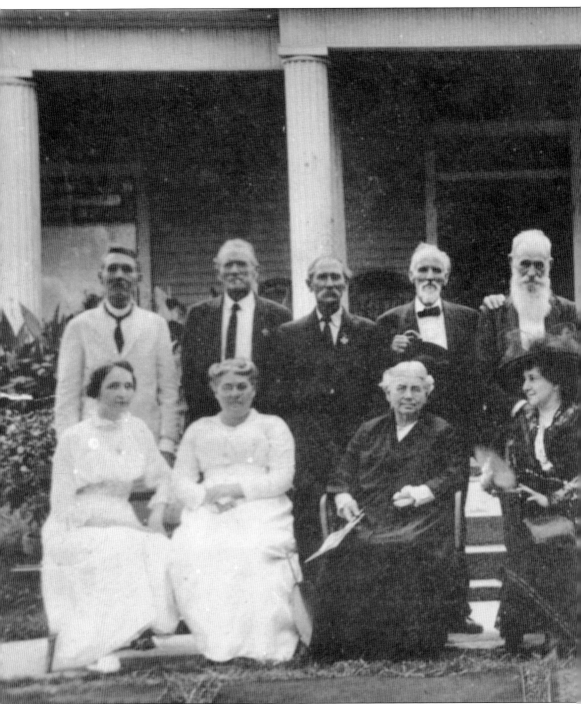

C.F. Hollberg and his lovely wife, Lillian (Sibley) Hollberg, hosted the Confederate Soldiers Luncheon in 1912 at the Hollberg Hotel. Ironically, C.F. was the only Yankee in town. Attendees included (first row) Lillian Hollberg, Emma Benton, Mrs. J.D. "Grun" Hunter, May Baggarly, Molly Sibley, Mrs. William Anderson, Bessie Harrison, and Mrs. J.D. Harwell; (second row): Harrison Summer, a Mr. Coggins, Tom Carlton, Berry Liles, John Dawson Johnson, C.F. Hollberg Sr., Will

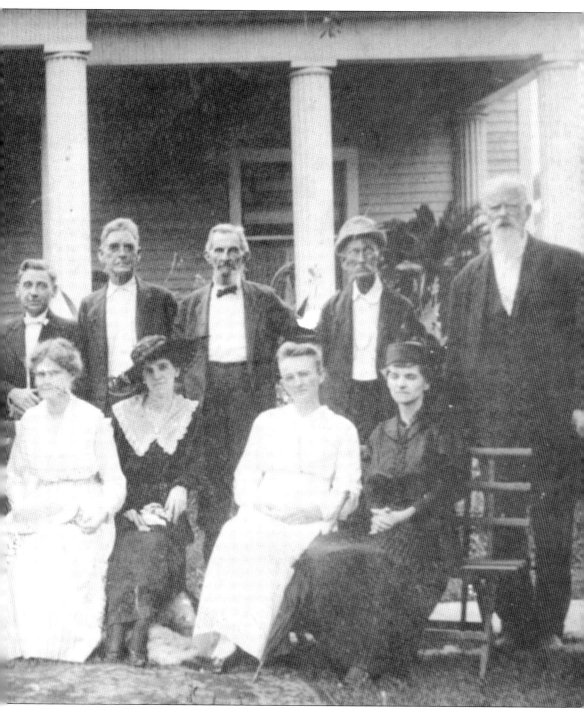

Odum, William "Bill" Anderson, E.T. "Daddy" Peek, and Jim Garrison. Confederate Veterans 19th Georgia Regiment, Company D captain J.D. Hunter was deceased prior to the 1912 luncheon. Some say Margaret "Peggy" Mitchell interviewed Confederate soldiers at the hotel for her best-selling book *Gone with the Wind*. Today, the Hollberg Hotel is the Veranda Bed and Breakfast Inn. (Courtesy of Janet Baggarly.)

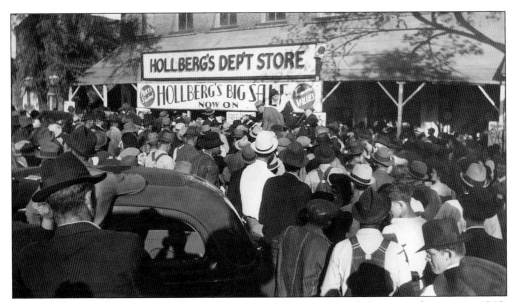

Men filled Main Street for Hollberg's Department Store sale and the town drawing in 1940. Customers received tickets with each purchase from downtown merchants and then brought their tickets back to town when a drawing was held. Duplicates of those tickets were put in a box and later pasted on a large piece of cardboard. Winners at the downtown drawing would receive prizes such as a 100-pound sack or flour or a large tub of lard, according to longtime Senoia resident James Barnette Sr. C.F. Hollberg Sr. died in 1955 after 61 years of business. His son Frank (C.F. Jr.) took over after his death, and in 1960, Frank's son (then known as "Buddy") brought modern improvements and furniture to the store. When C.F. Hollberg Jr. died, Buddy took on his father's name of Frank. Hollberg's Furniture store's bookkeeper, Amanda Whatley, purchased the store from Frank when he retired. (Courtesy of C.F. "Frank" Hollberg III.)

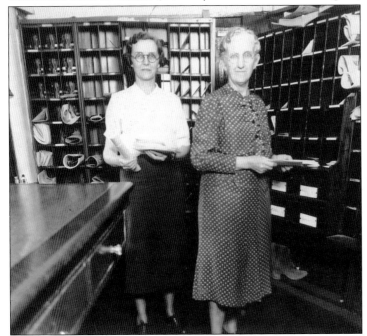

Frank Hollberg's maternal grandmother, Etta Arnall (right), served as postmistress from 1936 to 1951 when the post office was located where Hollberg's discount furniture is today. Etta worked with Susie Sullivan (left) at the time this photograph was taken in the 1940s. Susie Sullivan was the longest living charter member of St. Phillips Lutheran Church (established 1910), known today as the Church of God of Prophecy. (Courtesy of C.F. "Frank" Hollberg III.)

R. E. McKNIGHT MOTOR CO.

FORD AUTOMOBILES
PARTS
ACCESSORIES
GASOLINE, OILS, ETC.

AUTHORIZED *Ford* DEALERS

THE UNIVERSAL CAR

FORDSON TRACTORS

BARGAINS IN USED
CARS

LINCOLN AUTOMOBILES

❖

SENOIA, GA.,

Ralph McKnight was the first to sell automobiles in Senoia at R.E. McKnight Motor Company. McKnight's Ford/Lincoln dealership offered the opportunity to purchase automobiles, parts, accessories, gas, oil, and Fordson tractors. McKnight later sold his dealership to James Benjamin "J.B." Hutchinson, who renamed it Hutchinson Motor Company. This stationery from McKnight's dealership is one of many treasures that may be found in the Senoia Buggy Shop Museum. (Courtesy of Janet Baggarly.)

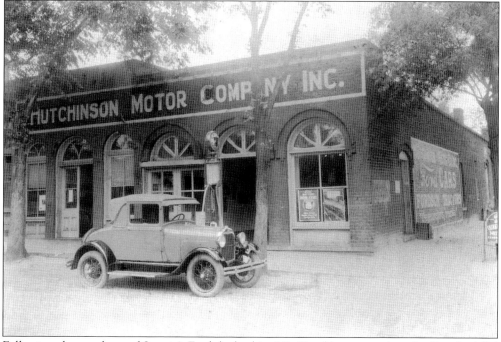

Following the purchase of Senoia's Ford dealership, J.B. Hutchinson purchased a Standard Oil franchise, which later became Gulf Oil. Hutchinson Motor Company became Hutchinson's Hardware in later years. Hutchinson's son Jimmy came home from the University of Georgia to run the family business when his father died unexpectedly. (Courtesy of Jane (Hutchinson) Arnold.)

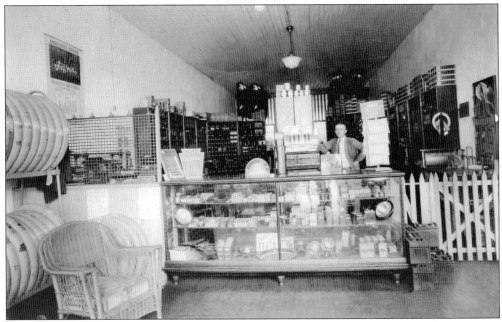

J.B. Hutchinson is depicted in the parts department of Hutchinson Motor Company. Hutchinson drowned in Hutchinson Lake in 1956, at which time his son Jimmy was called home from college to take over the hardware business later housed in this building. Kathleen told her son they could sell the business, but Jimmy thought he should carry on what his father had worked so hard to build. (Courtesy of Jane (Hutchinson) Arnold.)

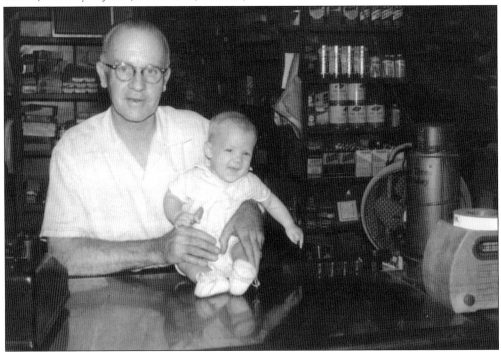

J.B. Hutchinson is depicted here inside Hutchinson Motor Company with his eldest grandson, Dr. Andy Smith, in the 1950s. (Courtesy of Jane (Hutchinson) Arnold.)

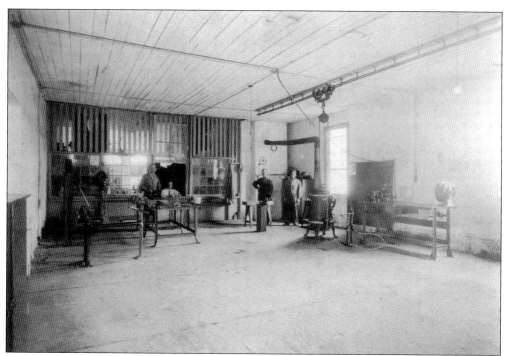

Hiram Todd was Senoia's mechanic, and he worked in the garage located on the Seavy Street side of the Hutchinson Motor Company building, where Matt's Pizza is today. At one time, Frank Harris worked as a mechanic at the garage with Todd. Pictured are, from left to right, Roy Shell, J.B. Hutchinson (seated in the window), Elbert Caldwell, and Hiram Todd. (Courtesy of Jane (Hutchinson) Arnold.)

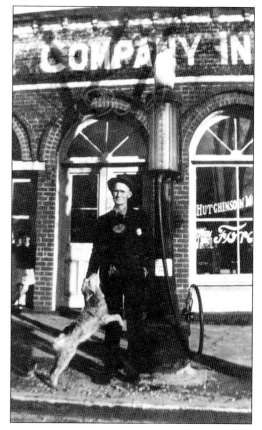

Senoia police chief George L. Welden stands outside Hutchinson Motor Company in 1940 with his dog and daughter Callie. Chief Welden's duties included handling water problems. Following a complaint about muddy water, his daughters Sue and Callie would gather their childhood friends and go around town turning on water hydrants, playing in the water until it ran clear. (Courtesy of Cynthia (Williams) Christopher.)

Benton Gill drove the Standard Oil truck during the 1940s and loaded it with tanks from the Atlanta, Birmingham & Atlantic Railway train at all hours. Little Jimmy Hutchinson rode along on a delivery and tattled that Gill did not allow him to put his feet on the dash. J.B. Hutchinson got a kick out of sharing the news with Gill, who did not want Jimmy scratching up his new truck. (Courtesy of Martha Gill.)

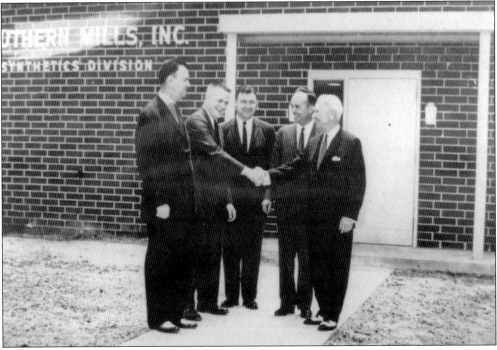

Southern Mills came to Senoia in 1940, employing over 200 workers at one time. Mayor Jimmy Hutchinson helped bring the Synthetic Division of Southern Mills to the city. This photograph was taken to commemorate its success. From left to right are Judge Byron Matthews, Mayor Jimmy Hutchinson, Clyde Lunsford, Doug Ellis, and Congressman Jack Flynt (shaking hands with Jimmy). (Courtesy of Jane (Hutchinson) Arnold.)

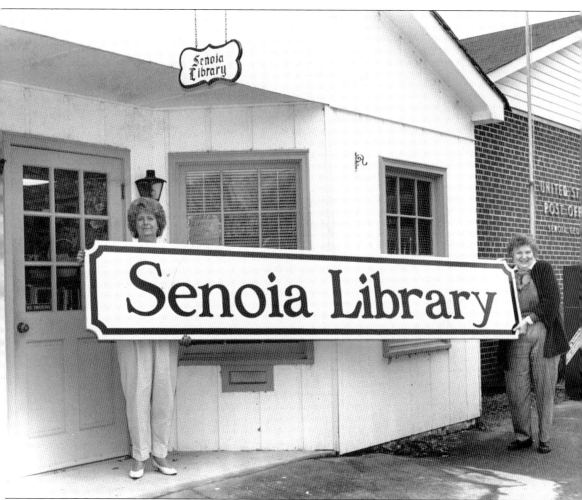

Betty Cookman (left) and JoAnne Utt (right) hold Senoia Library's first sign in front of the renovated city hall. Cookman was working with Jack Humphrey (who was in the book business) when he envisioned a library for Senoia. Humphrey and Cookman presented the library idea to the Senoia City Council on March 4, 1974. The library opened on July 8, 1974, with 2,000 books. Georgene Harris was the first manager of library volunteers. Ellis Crook loaned his truck to Humphrey and Cookman to pick up donated shelving from the Pine Mountain Regional Library in Manchester. Doris Dean of the Troup-Harris Regional Library in LaGrange provided a collection of books on extended loan. Jo Morgan made draperies from material donated by Southern Mills, and Floyd Hayes installed additional shelving. Beverly Bishop assumed full responsibility for the library as a volunteer librarian in 1974, improving the services of the library tremendously. JoAnne Utt was the first paid librarian, followed by Linda Drawdy, Alice Jones, Saundra Frank, Kathy Goodell, and Aime Scarbrough. (Courtesy of Betty (Cookman) Armstrong.)

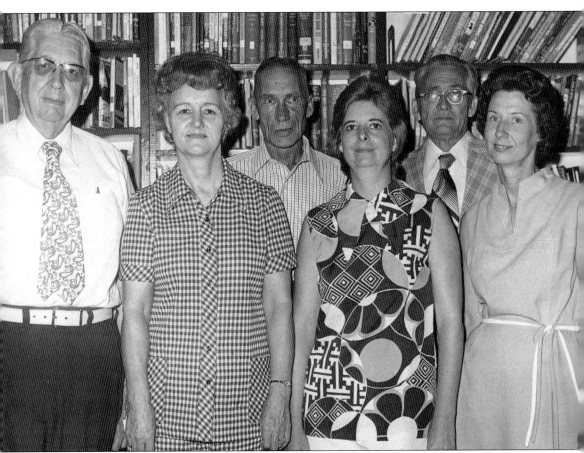

Mayor Frank Hollberg Jr. (left) appears with the first Senoia Area Library Board. From left to right are (first row) Sue Williams, Senoia First Baptist Church; Betty Cookman, who spearheaded the effort with Jack Humphrey (not pictured); and volunteer manager Georgene Harris; (second row) M.H. "Slim" Adcock, Senoia Lions Club; and chairman Ray Sewell, Senoia United Methodist Church. Vice chairman Harry Maddox and Billy Roesel are not pictured. First located on Main Street, visitors walked through city hall and the police area to the back where books lined the shelves of the city council room. Totsie McKnight (second board chair) picked up donated library chairs in LaGrange. She, Edith Lowry, Vera McKnight Adair, Mary Ann Reese, Jo Morgan, and Julie Humphrey were regular volunteers, in addition to others listed herein. The library's second location was at 68 Main Street, where the volunteer fire department was once housed. It moved back to the old city hall after it was remodeled and later moved to where Katie Lou's restaurant is located today before the new library was constructed on Pylant Street. (Courtesy of Betty (Cookman) Armstrong.)

Isadore Addy holds the hand of younger sister Kate, standing near Grandmother Morgan. Their brother Eulyss stands in back next to an unidentified boy. Eulyss was gassed during World War I, and his health was never the same. The three siblings never married and operated Addy's grocery store together on the site of present-day Foxhollow Antiques and Uniques. The store is remembered for its delicious hot dogs, said to be unlike any other. (Courtesy of Patricia (Yarbrough) Crook.)

Eulyss, Isadore, and Kate Addy's grocery store (front right in 1949) was famous for its hot dogs. Families purchased them a dozen at a time, most on credit. The store's accounting system for hot dogs consisted of multiple small, brown paper bags noted with family names and a tally of hot dogs tacked up by the counter near a large copper appliance, which offered the magic of steamed buns. (Courtesy of Tray Baggarly.)

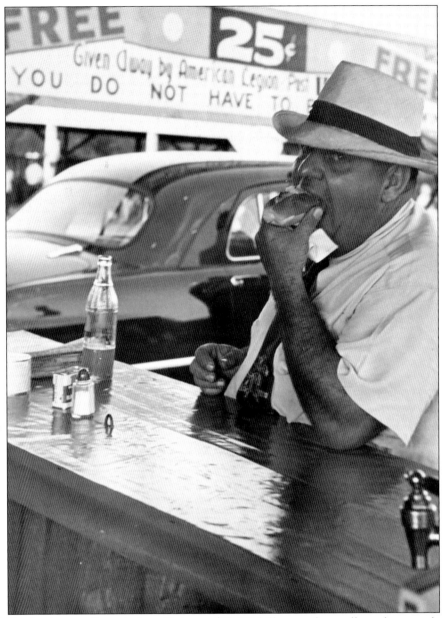

Dock Tinsley (pictured) routinely pulled out a $10,000 bill to pay for small purchases and ask for change. He enjoyed the shock factor but carried a pistol in his pocket in case of trouble. Kate and Isadore Addy are described as "unclaimed blessings," as they never married. The store they ran with their brother Eulyss sold salted pop-eyed mullet from a wooden barrel and ice-cold Nehis, but the town's favorite treat was found near a copper steamer that sat on a long, wooden counter. Upon entering the store, one could hear the sound of Isadore's quick pounding knife as she diced onions for the store's delicious hot dogs, which were served in soft, steamed buns. Longtime Senoia residents declare the Addy's hot dogs (known as "KateAddies") topped with finely diced onions, coarse black pepper, and mustard were the best they ever tasted. In fact, of all the stories retold by Senoia residents, the story of Addy's hot dogs is by far the one retold the most. Tinsley loved hot dogs and was a regular customer. (Courtesy of Natalie (Tinsley) Mrotzek.)

Harold and Kathryn Tinsley Awtry ran the Pineview Grill, which was located catty-corner across the street from Roy Tinsley's station at the intersection of Highways 16 and 85. Bill Tinsley remembered the Pineview Grill as "a little concrete block building with a counter and two or three booths. It was really a treat to go and get a hamburger there when I was a kid." (Courtesy of Gary Welden.)

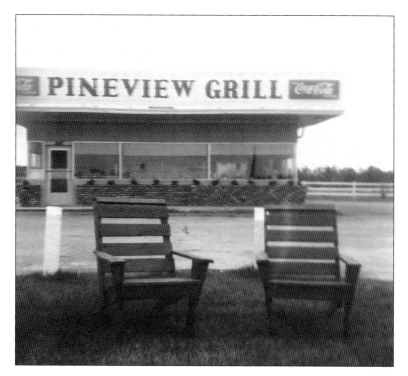

Kathryn Tinsley Awtry ran the Pineview Grill (top left) with her husband, Harold "Hal" Awtry. Geoff Tinsley recalls playing Little League baseball behind the restaurant and how special it was to eat there after a game. (Photograph by Melvin Cheek; courtesy of Geoff Tinsley.)

Roy Tinsley was the son of Dock Tinsley. He owned Roy Tinsley's Amoco Station at the intersection of Highways 16 and 85 and was the visionary behind Senoia's residential flying community: the Big T Airport. In this photograph, Roy stands in front of his service station in 1954. (Courtesy of Gary Welden.)

<table>
<tr><td>Wrecker Service</td><td>Phone 28</td></tr>
</table>

TINSLEY'S SERVICE STATION

Roy Tinsley, Owner

AMOCO TIRES · BATTERIES · ACCESSORIES
WASHING · LUBRICATION

Jct. Hwys. 85 & 16

Senoia, Ga.,, 195....

Name *William Tinsley*

Address

	GALS. GASOLINE		
	QTS. OIL		
	WASH		
	LUBRICATION		
	Repair Radiator		$5.50
		TAX	
		TOTAL	

Rec'd by

BEST SALES BOOKS, P.O. BOX 60, HENDERSONVILLE, N.C.

X1

This 1950s Tinsley's Service Station receipt is for a $5.50 radiator repair. "Full service" meant not getting out of the car except to use the restroom. Free window washing and a check of all fluids came with every tank of gas, which an employee pumped into the vehicle. Attendants also checked air in the tires and added air, if needed. (Courtesy of Peggy (Tinsley) Hall.)

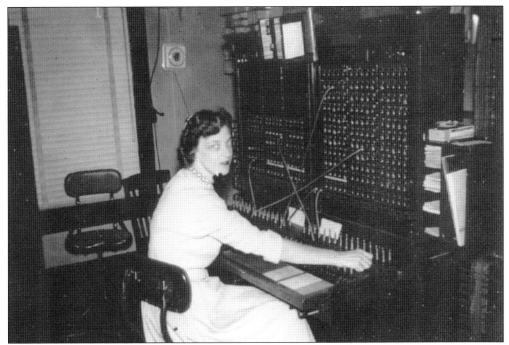

Jacqueline (Turner) Whitlock is pictured here running the switchboard at the Senoia Telephone Exchange when it was located at 265 Seavy Street in a house built in 1927. (The small, gray house still stands.) As a boy, Hal Sewell would dial 0 and ask to speak to his "mama." The switchboard operator connected the call without hesitation to Sewell's Store on Main Street. (Courtesy of Nancy Roy.)

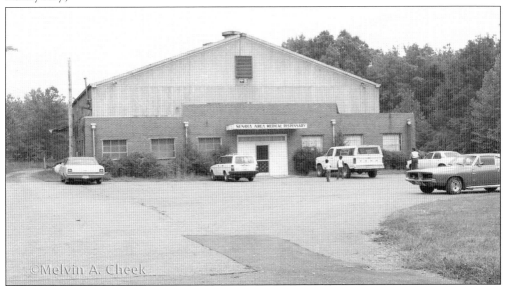

Once Brantly Institute's Clark Street gymnasium, this building sat one block east of the Methodist church. Wrestling matches were held here before it became the Senoia Area Medical Depository (open in the 1970s and 1980s), which used the back of the building for storage and housed doctor's offices in the front. Both Dr. Donaz and Dr. Ivonovik offered sports physicals in this location. (Photograph by Melvin Cheek; courtesy of Geoff Tinsley.)

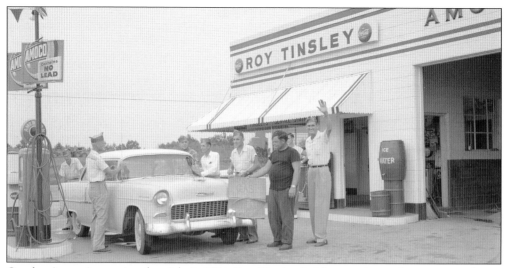

On the Amoco's opening day, July 3, 1954, Roy Tinsley holds up a sign to let customers know proceeds of gas sales that day were going to the Senoia Lions Club. Pictured are, from left to right, unidentified; J.P. Irving (back of car), who served as the first gas attendant; Billy Roesel (plaid shirt); two unidentified; Tinsley; Pete Bedenbaugh (waving), and unidentified (background). Roesel played Santa Claus at Hollberg's store and is remembered for making people laugh, even unto death. At this funeral, "Roll Out the Barrel" played as his casket left the church. (Photograph by Melvin Cheek; courtesy of Geoff Tinsley.)

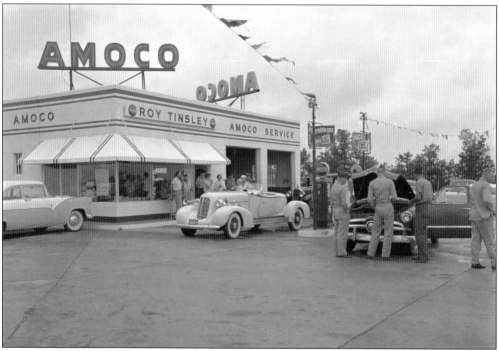

A variety of automobiles were serviced at Roy Tinsley's Amoco Station grand opening celebration on July 3, 1954. In this photograph, one can see a 1954 Ford on the left and what appears to be a 1935 Auburn. At right, attendants service a 1940 Ford. (Photograph by Melvin Cheek; courtesy of Geoff Tinsley.)

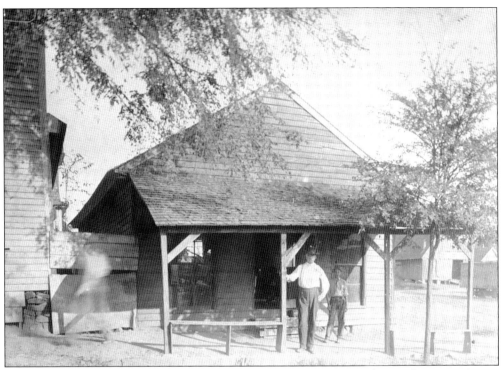

Benjamin Atticus Nolan stands behind his father, John, at Nolan's store (c. 1890s) on Main Street. A printing press housed in a small, wooden building behind the store printed the *Enterprise Gazette* until the 1920s. The wooden building is no longer there, but evidence of it remains at the back of the brick café, which replaced the wooden store in the 1920s. In later years, D. Hunter picked up mules from trains and sold them at a barn behind the café building. (Courtesy of David and Suzanne Pengelly.)

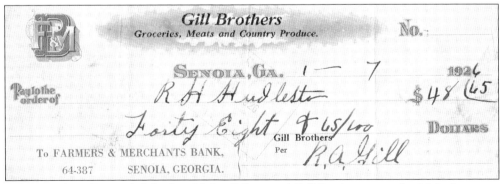

Farmers Robert (Benton's father) and John Gill opened Gill Brothers store after Nolan's grocery closed. Depicted is a 1926 Gill Brothers receipt. Bruce Fry's Red Dot Store occupied the space before moving across the street. Bill Smith opened his real estate office here at one time. In the 1970s, the McKnight family used the building to store corn before it was renovated by David and Suzanne Pengelly, who opened Senoia Coffee and Café. (Courtesy of Marla (Gill) Dugan.)

Senoia teenagers Sue (Welden) Williams (Senoia police chief George Welden's daughter) and Ellis Crook (son of Arry Lee Crook) were schoolmates at Senoia High School in the Brantly Institute. Sue and her parents, children, and grandchildren have shopped at Crook's grocery store (now Crook's Marketplace, Senoia's first supermarket) for decades. (Courtesy of Sue (Welden) Williams.)

Ellis Crook is pictured with his parents, Arry Lee and Leola (Addy) Crook, in the late 1930s. Arry Lee opened a grocery store on Highway 16 in 1913. His son Julian created the slogan, "Get an Honest Deal from a Crook," which is still printed on grocery bags at Crook's Marketplace. Ellis began running the family store full time at the age of 19 when his father was ill. (Courtesy of Ellis Crook.)

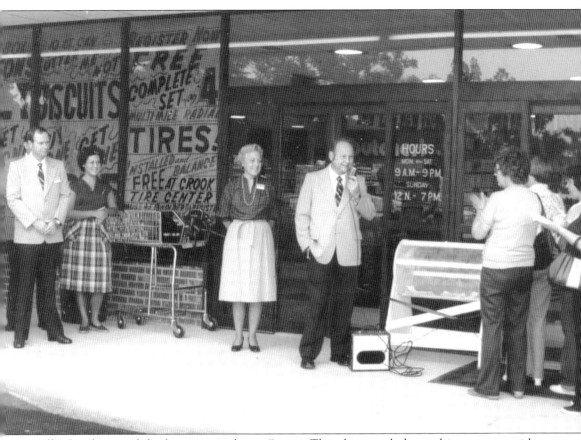

Ellis Crook opened the first supermarket in Senoia. This photograph depicts him at center with his wife, Patricia (Yarbrough) Crook (immediate left), and his daughter Cheryl (Crook) Thompson, smiling at her dad (far left). All others in this photograph are unidentified. In 1943, Arry Lee Crook sold a couple of mules to purchase a building across the street from present-day Crook's Marketplace. Longtime Senoia residents recall a huge variety of items in Crook's small store. In 1947, Crook purchased the land where the gas station and convenience store are at the corner of Broad Street and Highway 16 today. Ellis purchased the business from his father in 1960 and opened Big Buy, then Big Guy, and finally Crook's Marketplace (the first Senoia business with air-conditioning) adjacent to his Hit N Run gas station across Broad Street in 1981. (Courtesy of Pat Crook.)

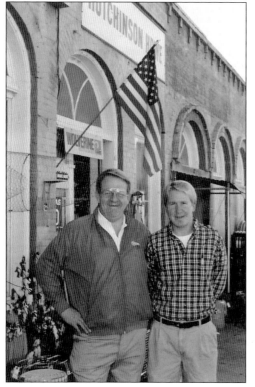

Jimmy and Jane Hutchinson worked together at Hutchinson Hardware, which was packed to the rafters with everything imaginable. Remnants of previous decades could be found throughout the store. People sometimes wondered how anything could be found, but Jimmy always put his hand on whatever was needed. At the going-out-of-business auction for Hutchinson Hardware, a wooden washing machine in its original crate that had not sold in 1922 was brought out to sell. (Courtesy of Jane (Hutchinson) Arnold.)

Jimmy and Jim Hutchinson stand outside Hutchinson Hardware. Although told not to play in the street, little Jim sometimes did, and Jimmy always knew. Jim once asked his dad how this was possible. Jimmy led his son to a high spot inside the store where their family home came into view. Jim then understood that he was always under his father's watchful eye. (Courtesy of Jane (Hutchinson) Arnold.)

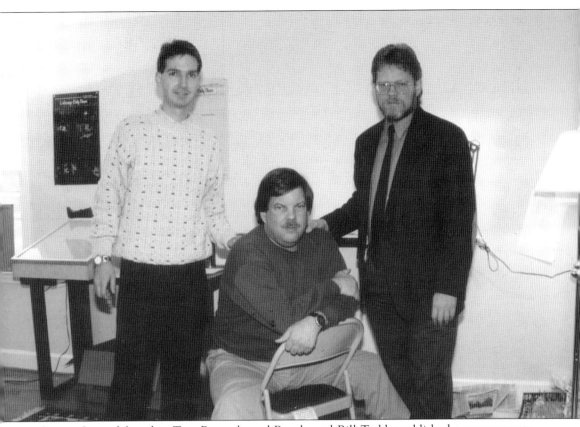

Coweta Journal founders Tray Baggarly and Randy and Bill Todd established a newspaper to offer current events, local history, and sports. According to Tray Baggarly, the men established Community Press Inc., which printed the first issue of the *Coweta Journal* on November 30, 1995 and covered news for Haralson, Senoia, Sharpsburg, and Turin. Bill notes, "Tray, Randy and I agreed that the eastern end of the country was not given the news coverage it deserved. We wanted to promote human interest stories from our end of the county and coverage for our schools. Tray had newspaper experience with *This Week in Peachtree City*, and its founder, Jimmy Booth, advised us as we established the newspaper. Jimmy was not optimistic that it was a great business venture, but we did it anyway, using Tray's expertise to teach Randy and me what we needed to do. Tray worked at the newspaper full time, and I worked daily alongside him. Randy, who is computer savvy, set up the layout and thereafter helped out as needed. Carl McKnight and Gary Sykes worked as photographers for sporting events." Baggarly served as operations manager, Nancy Hand was the office manager, and Sally Hope handled advertising. Jack Merrick, Blue Cole, and Judy Etheridge contributed news stories along with others. The newspaper's first office was housed across from the old post office in downtown Sharpsburg. The office then moved to the old clock shop building on Broad Street in Senoia. In 1997, it moved to Senoia's old post office building on Main Street. According to Baggarly, the publication was sold to Millard Grimes of Grimes Publications in 1999. Grimes renamed the newspaper *Senoia Home News*, publishing the first issue on July 22, 1999. On January 31, 2002, Grimes sold the publication to Robert Tribble, who renamed it the *East Coweta Journal*. Its first issue debuted on February 7, 2002. Baggarly remained at the Senoia office as managing editor of the publication until it ceased in 2017. Back issues of the Senoia publications noted herein have recently been donated to the Senoia Area Historical Society Museum where they are available for the public to view upon request. (Courtesy of Gary Welden.)

East Coweta High School graduates Chris Hanson (left) and Keith Brooking (right) represented Senoia in the National Football League. Hanson began his career with the New England Patriots, and Keith Brooking started with the Atlanta Falcons. Carl McKnight and Bill Todd of the *Coweta Journal* had the privilege of covering games (including Super Bowl XXXIII in which Brooking played) for the newspaper. Blue Cole wrote an occasional article while in high school. (Courtesy of Carl McKnight.)

Carl McKnight stood on the sidelines as Atlanta Falcon Keith Brooking played during Super Bowl XXXIII. McKnight was the *Coweta Journal*'s sideline photographer. The initial location for the *Coweta Journal* office was in Sharpsburg. It later moved to the building between Senoia's new post office and the garden center, with its final location in the old post office on Main Street. Judy Kilgore was the receptionist. (Courtesy of Carl McKnight.)

Two

KING COTTON AND FARM LIFE

Capt. William David Linch was a Confederate captain, one of Coweta County's largest cotton producers, and the father of Mary Linch, who married Carl McKnight. Captain Linch and his unit surrendered with Gen. Robert E. Lee at Appomattox. Long into the 20th century, cotton was king in Senoia, with 8,500 bales of cotton marketed in the city in 1899. With profits from his thriving cotton crop, Captain Linch built a two-story home for his family on Pylant Street and later constructed Senoia's grandest home for Mary and Carl, which is located to the left of the Linch family homeplace. Linch family members are buried in the Senoia Cemetery on Standing Rock Road. (Artwork by Melissa (Dieckmann) Overton.)

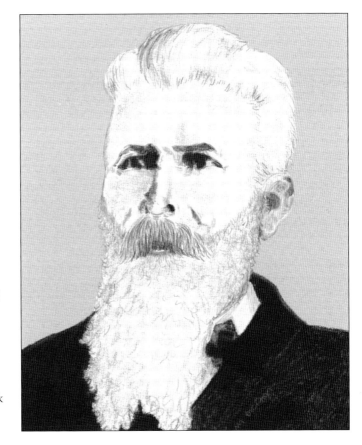

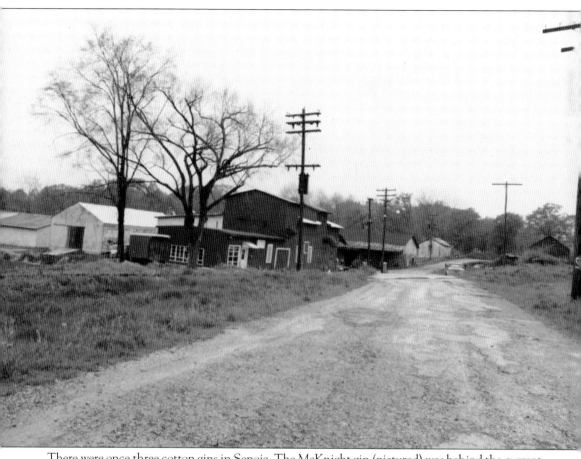

There were once three cotton gins in Senoia. The McKnight gin (pictured) was behind the current post office near the Central of Georgia Railroad, where the *Walking Dead* backdrop is today. The entrance to C.P. Daniel's gin was located where the cement block building that once housed the clock shop and office of the Georgia Tour Company is on Broad Street. The R.L. Arnall gin was located on the east side of the AB&A Railway off Seavy Street. (Courtesy of Randy Todd.)

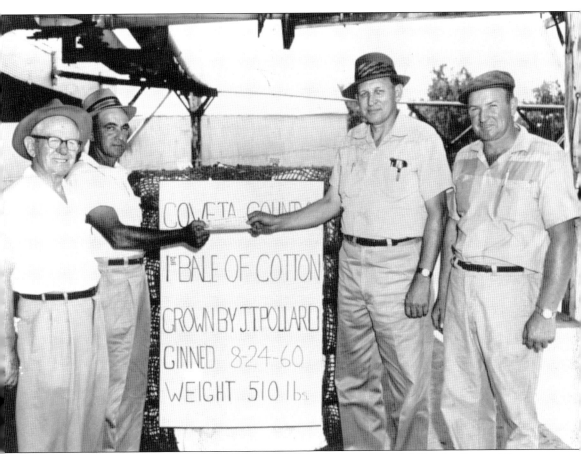

Gulf station owner J.T. Pollard delivered the first bale of cotton to the McKnight Cotton Gin on August 24, 1960. Pollard (second from left) is receiving a check from Bill Estes. Pictured with the men are Paul McKnight Sr. (left) and Paul McKnight Jr. (right). Paul McKnight Sr. was a deacon for Senoia Baptist Church, a World War I veteran, Senoia Lions Club charter member, and a two-term city councilman. He died in 1984 at the age of 97. Paul Jr. joined the family business after his uncles Ralph and Carl died. (Courtesy of Frances Pollard.)

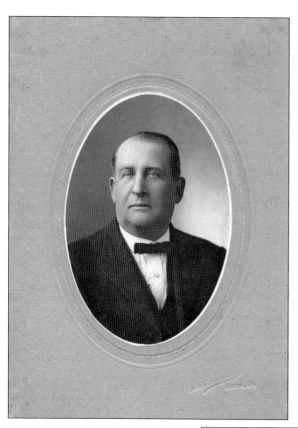

J.A. McKnight (pictured here) was the patriarch of the McKnight family. An astute businessman, he established the McKnight family enterprise with his sons Ralph, Carl, and Paul in 1902. In addition to their own farm, the McKnight businesses were welcome resources for area farmers who needed to gin cotton and make use of the grain elevator or purchase fertilizer and other products for their farm and home. (Courtesy of Carl McKnight.)

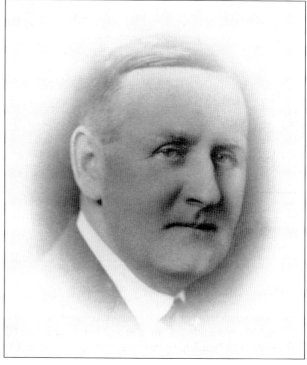

Carl McKnight (depicted here) ran a peach orchard on Rock House Road when neighbors Frank Daniel, Bill Row, Lee Hand, R.W. Freeman, and Oscar Mann also had orchards. Locals harvested and packed peaches for the most part, but German prisoners of war made up part of the workforce during the 1940s. Carl McKnight was Paul McKnight Jr.'s favorite uncle, for whom he named his son. (Courtesy of Carl McKnight.)

Hayward Bishop (in his International cotton picker) began farming in the late 1940s. He; his wife, Hazel; and their six children, Roy, Martha, Perry, Jerry, Linda, and Connie picked and chopped cotton by hand. Jerry Bishop notes, "In first grade, we began picking cotton from sunup until sundown. Female field hands helped out to earn extra money. If their children were out of school or too young to go, the women would bring them to the field to pick. The pay back then was only 2¢ a pound. When cotton needed to be thinned, we had to chop it. To get the grass out from under it, we had to hoe it. This is before weed killer and stuff like that. We thought it was the greatest thing in the world when daddy bought his cotton picker, and we no longer had to pick cotton by hand." Connie (Bishop) Sharp recalls the fun she and her sister Linda (Bishop) Sutherland had playing in giant bales of cotton, building tunnels together. (Courtesy of Connie (Bishop) Sharp.)

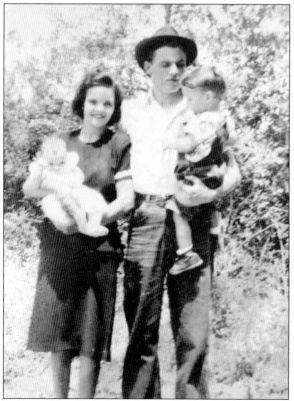

Linda, Martha, and Connie Bishop stand in a hayfield at their family farm. Hayward Bishop planted cotton, corn, hay, soybeans, and wheat. Linda recalls selling Silver Queen corn to Ellis Crook at his original store. Connie shares, "Ellis told us there was more love in our house than in all of Senoia." Jerry Bishop relates, "We had everything we needed and most everything we wanted." (Courtesy of Roy Bishop.)

Hazel and Hayward Bishop hold their children Martha and Roy in 1948. Martha thanks God for the wonderful life she has known in her family. The Bishop children left school at noon to help bring in cotton during harvest time. Hazel made a good breakfast each morning and cooked a large meal in the afternoon, which provided leftovers for supper. (Courtesy of Connie (Bishop) Sharp.)

The oldest of Hazel and Hayward Bishop's six children, Jerry had a great time camping and riding horses with his cousins; brother Perry; and Sammy, Stanley, and Bob Cooper when he was not working on the family farm hoeing, picking, or chopping cotton. Jerry recalls, "Hollberg had a small store with two gas pumps downtown, and we rode horses there to get a snack before riding back out of town. When it was 90 degrees, we rode to Doc Morgan's pond, where we took the saddles off our horses and jumped off the bank into the pond on their backs. The horses would swim to shore as soon as they got into the water. Afterward, we rode to our campsite miles away. (Most of our group was drafted for the Vietnam War in 1967.) I have ridden horses pretty regularly since I was young, going on a trail ride just last year. My brother Perry won a rodeo and worked on Pitchfork Ranch, Four Sixes, and then a wagon ranch in Texas. He was the real cowboy in the family." (Courtesy of Roy Bishop.)

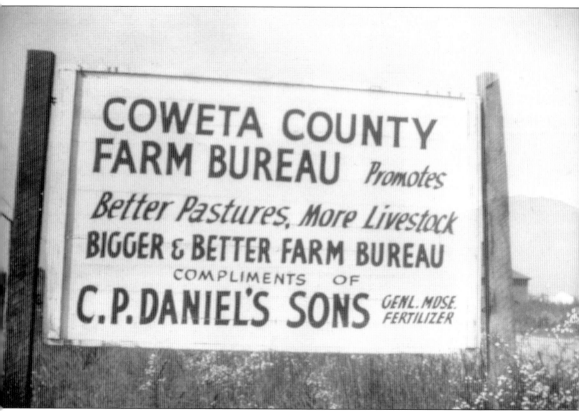

Jim Baggarly Sr. photographed this Coweta County Farm Bureau sign in 1949. There were two dairy farms in Senoia that year. Love Brandenburg had one behind Main Street (where the grass-covered, brick parking lot is currently) adjacent to his Seavy Street house (the Merrick home), and Berry Whatley had a dairy barn on Highway 16. James Barnette, Bobby Hatchett, and brothers Walter and Warren Baggarly delivered milk for Brandenburg. Barnette recalls helping bottle milk over several summers. He relates, "While Mr. Brandenburg drove, I would stand on the running boards of his Model A and pull bottles out of the passenger seat. When he stopped, I stepped off and put the bottles on the porch." Hatchett describes Brandenburg as a big man with a good disposition except when it came to politics: "He was a like a 'banister walking preacher' throwing his hat on the ground and ranting and raving about politicians at Parks Barber Shop until the stores closed at 9:00 on Saturday night." (Courtesy of Tray Baggarly.)

Five generations have lived and worked on what Ronnie Whatley calls "493 acres of God's green earth in the sun-kissed Dixie land of Georgia." He knows every nook, cranny, hill, and dale of the farmland his forefathers occupied before him. Cows graze near the dairy barn on Berry Whatley's farm in the 1950s. Cows were milked beginning at 5:00 a.m. (Courtesy of Susan (Robinson) Whatley.)

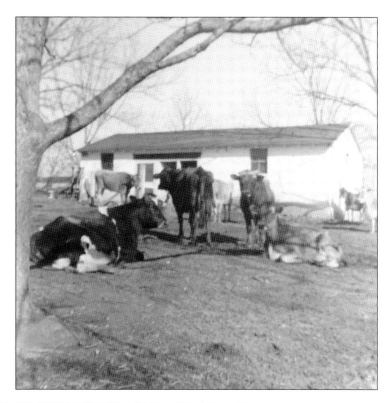

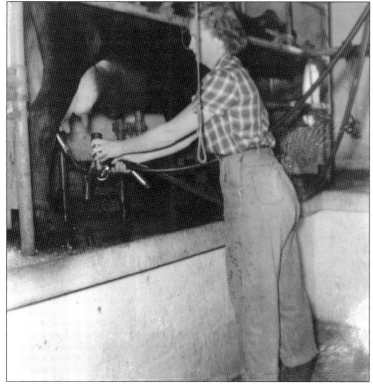

Dorothy Whatley milks cows at the Whatley dairy barn she ran with her husband, Wilson, in the 1950s. The parlor-type barn was the first of its type built in Coweta County. A parlor barn was constructed of concrete and did not have a traditional dirt floor. (Courtesy of Susan (Robinson) Whatley.)

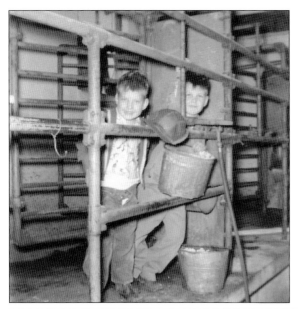

Brothers Ronnie (left) and Jerry (right) Whatley play in the dairy barn. Ronnie knows the location of the 100-year-old well dug into a natural spring, where the first timber was cut from the property, and where wild Easter lilies bloom in such abundance that the ground appears to be covered with snow in the springtime. (It is the place where the crickets sing the loudest.) (Courtesy of Susan (Robinson) Whatley.)

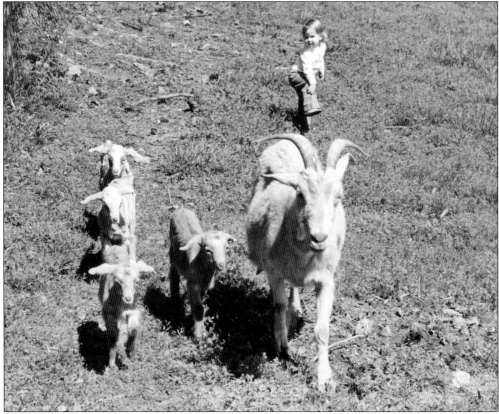

Here, two-year-old Pollyanna Whatley is running with goats. This orphaned nanny goat was bottle fed as a baby. A goat only has two teats, so it is nearly impossible for a mother goat to care for four kids. Susan Whatley relates, "She must have remembered what it was like to be an orphan because she raised all four of those goats by herself, which is rare." (Courtesy of Susan (Robinson) Whatley.)

High school sweethearts Ronnie and Susan (Robinson) Whatley continue the legacy of Berry Whatley at the family farm, rearing their children and raising cattle, hogs, and goats. Susan shares a compelling interest in genealogy with her husband, and together, they have traced the Whatley roots to 1685. This image was captured around 1972. (Courtesy of Susan (Robinson) Whatley.)

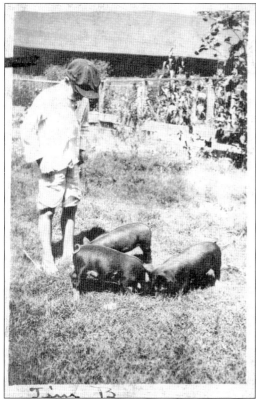

Young Jim Baggarly Sr. is shown here in the front yard of his home on Baggarly Way in 1912 with his pigs. It was common in those days for families to have livestock on an acre or less of land. Some families had milk cows, chickens, pigs, and goats as food provisions for their families. Most had a large garden as well and literally grew everything they ate. (Courtesy of Janet Baggarly.)

William Tatum Neill (1848–1898) bought his favorite mule at the mule barn located on Barnes Street behind what is now McMaster's BBQ in Senoia. They developed a special bond, and Neill wrote a tribute to his animal friend when he died in 1898. Kentucky plowed his fields, transported his bride to their residence, carried the couple to church, and proved dependable. Neill was the brother of Peggy Tinsley's great-great-great-grandmother Matilda (Morgan) Maximillian. The Morgans were some of Senoia's earliest settlers. (Courtesy of Peggy (Tinsley) Hall.)

Jim Wilkes drives his iron-wheeled wagon from the Senoia countryside to downtown for supplies. This photograph was taken in the 1940s. (Courtesy of Randy Todd.)

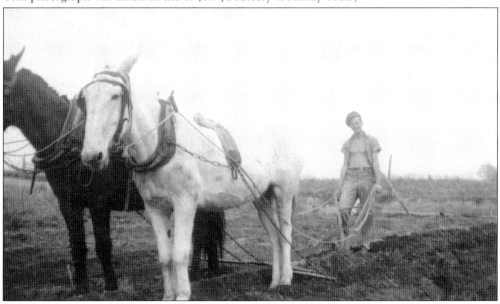

Reuben Williams plows cotton on the family's farm in 1946. During World War II, Williams took a year off from school at the Brantly Institute to work on the family farm. The seventh of eight children born to Carl and Hazel Williams, Reuben was four when his family moved to Senoia in 1931. As of 2021, Reuben Williams has lived on the family farm for 90 years. (Courtesy of Cynthia (Williams) Christopher.)

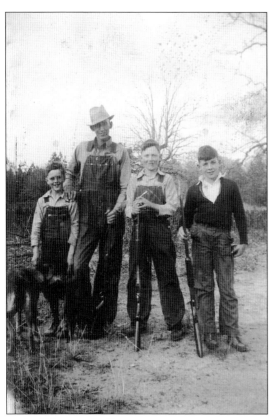

Pictured in 1939 are, from left to right, eight-year-old Reuben Williams, George Kempson, 13-year-old David Williams (Reuben's brother), and Ralph Jones Jr. (first cousin to Reuben and David) going rabbit hunting in Senoia. (Courtesy of Cynthia (Williams) Christopher.)

Tom and Laura Cook owned the first Cook grocery store on Main Street. The Cooks had four boys: Howell, David, and twins Robert and Wilbur, who were all born at the family residence on Morgan Street. The children, depicted at home, are, from left to right, (first row) Wilbur; (second row) Howell, Robert (Wilbur's twin), and David. (Courtesy of Frances Pollard.)

Carl and Hazel Williams are pictured here on their wedding day in 1908, at which time Hazel had a 13-inch waist. The couple purchased a 150-acre farm on what is now Carl Williams Road in 1941, and they raised eight children: Carl Carter Jr., Will Simpson, Rosalind, Dan, Marie, David, Reuben, and Jeanette. (Courtesy of Cynthia (Williams) Christopher.)

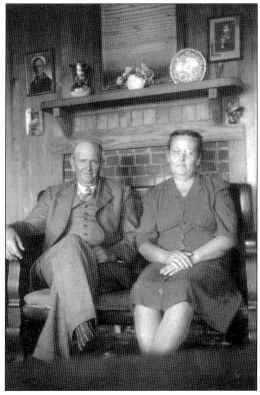

Carl and Hazel Williams sit in the living room of their home on the family farm on Carl Williams Road. In the background, there is a photograph proudly displayed of their son Reuben, who was in the Merchant Marines. The Williams family worked together in their large garden and cared for cattle and pigs in addition to growing cotton. (Courtesy of Cynthia (Williams) Christopher.)

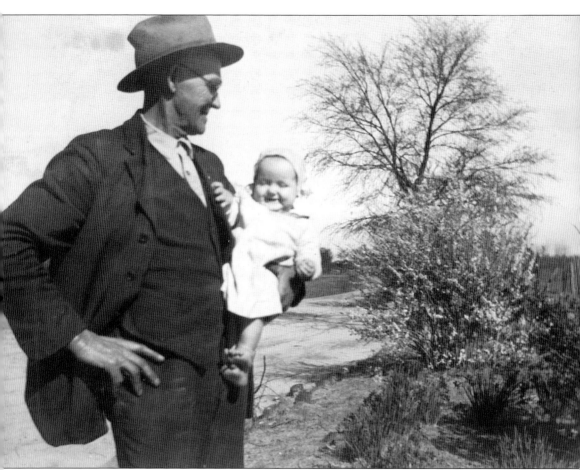

Luther Bailey had a large farm on Luther Bailey Road, where he and his wife, Virginia (Thurmond) Bailey, raised eight children: Martha Cornelia "Mattie," Annie Lizzie, Eula Mae, John Foster (John Tidwell's namesake), William Austin, and Paul Anderson. Luther holds his granddaughter Annie Ruth Crawford (daughter of Eula Mae, who grew up to be John Tidwell's mother) in this 1927 photograph. John recalls a story his mother told him: "Luther received a pair of 'store-bought' pants (which was a pretty big deal) for his birthday as a boy. Soon thereafter, he heard the news that Yankees had entered Coweta County. Worried the intruders would steal his pants, Luther buried them in the woods, later forgetting where." Luther was the kind of man who invited the preacher to come eat at his house after church on Sunday. Family members have wonderful memories of time spent on the farm. (Courtesy of John Tidwell.)

This 1934 photograph features, from left to right, unidentified, Luther Bailey, and his second wife, Lizzie (Crawford) Bailey, at his home on Luther Bailey Road. At one time, the house had two stories. Years after Luther Bailey died, the second story was torn off (perhaps due to storm damage), and a new roof was added. The house stands today as a one-story structure and is currently occupied. (Courtesy of John Tidwell.)

The daughter of Johnny and Wreathy Williams, Martha (Williams) Gill (pictured in 1930) moved to John Addy's place where the Morgan/Caldwell reunions were held when she was 10 years old. Working hard alongside her family, she helped plant, chop, and pick cotton in addition to sawing down trees with her daddy. The family raised everything they ate and canned vegetables, dried fruit, and milked cows. (Courtesy of Martha (Gill) Dugan.)

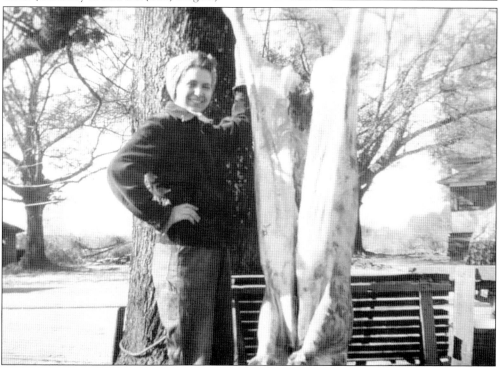

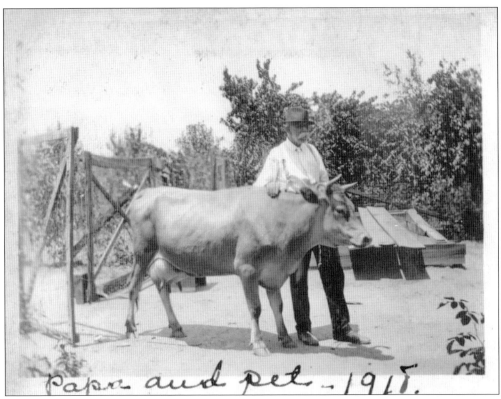

Papa and pet — 1918.

Willis Sidney Travis walks with a pet cow in 1918. It was once common to keep a milk cow and chickens on an acre or less of land. The area where Travis kept his farm animals faced the street that bears his name (Travis Street). Travis Street is located near the Central of Georgia depot site, where Travis served as the second railroad agent in Senoia. (Courtesy of Barbara (McDaniel) Ray.)

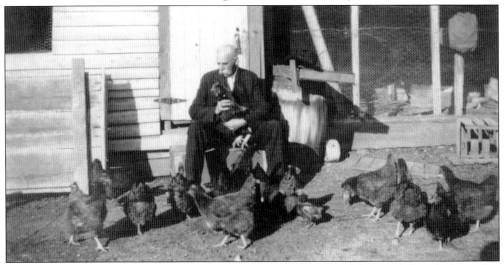

Willis Sidney Travis was very much an animal lover. He is pictured here with his chickens that provided fresh eggs daily for his family. Willis and his wife, Estelle (Vining) Travis, lived with their family in what is now commonly known as the *Fried Green Tomatoes* house. (Courtesy of Barbara (McDaniel) Ray.)

Three

A FLYING COMMUNITY

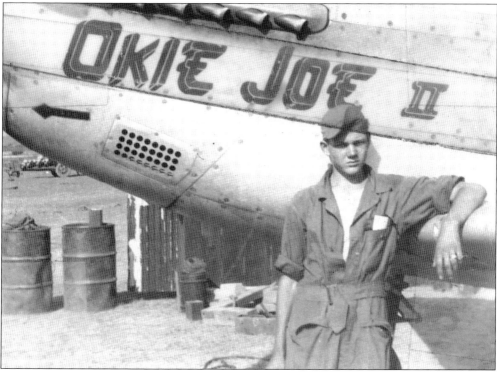

An airplane pilot, mechanic, and enthusiast, Edgar Todd was a major influence for aviation in Senoia. Todd flew the *Okie Joe* plane while serving in the Army Air Corps during World War II. He worked for Eastern Airlines afterwards, going on strike against Eastern in the early 1960s and never returning. He owned several planes, including a Stearman, when he started crop dusting in 1962. His dream was for his son Randy to solo and get his pilot's license before he received his driver's license at age 16. Randy fulfilled his father's dream, soloing out of the Newnan Coweta Airport. In addition to teaching his son, Edgar taught Jerry Tinsley to fly and encouraged Roy Bishop to take flying lessons in Griffin. Jerry Bishop and his sister Martha (Bishop) Lambert recall working in the fields on the family farm around the time of the Cuban missile crisis. Martha relates, "Mr. Edgar flew low over the fields, and the hired hands started screaming because they thought a war with Cuba had started." (Courtesy of Randy Todd.)

Edgar Todd is working on Jerry Tinsley's Piper J-3 Cub airplane in this photograph. Tinsley's hangar was within walking distance of Todd's house on Leylor Lane, which was next to the landing strip Tinsley used. Todd and Tinsley were great friends and enjoyed hunting together in the open fields across the street (where subdivisions are today) in addition to their mutual appreciation for aircraft. (Courtesy of Randy Todd.)

Randy Todd plays next to an airplane he received for Christmas at the family home on Pylant Street. When he was a little boy, he thought the street where he lived was named Pilot Street for his daddy, Edgar Todd, who provided flight instruction for several people in the Senoia community. (Courtesy of Randy Todd.)

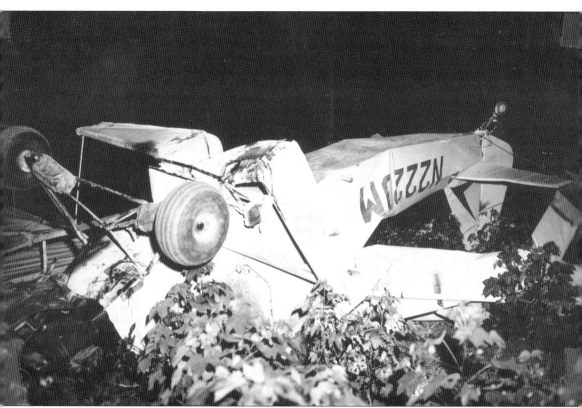

It was touch and go for Edgar Todd after the wing of his plane clipped a power line while he was crop dusting and crashed into the McKnight cotton field in August 1964. Two years earlier, Todd was teaching Jerry Tinsley to fly, and they crashed in the same field just 200 yards away from the second crash. Randy, Bill, and Brantly Todd stayed with Paul McKnight Jr.'s family while their mother, Mary Brantly Todd, stayed with her husband, who was in the hospital for several weeks. When Edgar rallied, the doctor informed him that he would never fly again. Although it took several years to recover, he began flying again three years later. Thereafter, Edgar worked as a mechanic for Republic Airlines, which became Northwest Airlines shortly before he retired. (Courtesy of Randy Todd.)

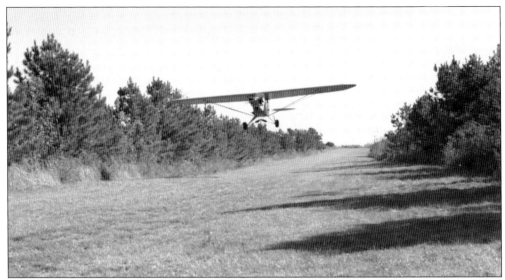

Jerry Tinsley's Piper J-3 Cub lands on his brother Roy's airstrip in 1977. Roy purchased the Daniel peach orchard, which included the airstrip, soon after Jerry returned home from serving the Navy. With the help of his son Wayne, Roy extended the runway to 2,200 feet. Today, the airstrip is the center of the Big T Airport. (Photograph by Melvin Cheek; courtesy of Geoff Tinsley.)

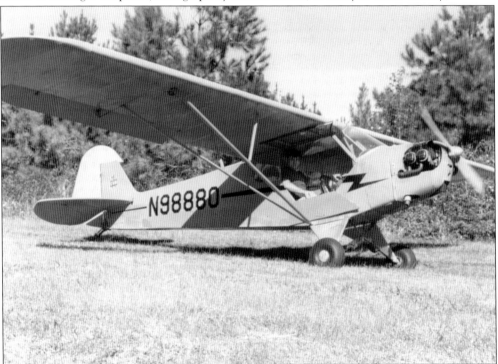

Jerry Tinsley is pictured in his Piper J-3 Cub in 1977. After serving as a Navy fighter pilot, Tinsley applied to fly for Delta Airlines. The hiring process took several months. Meanwhile, he started a construction and grading business with his brothers William and Roy, which landed the job of grading for Shannon Mall in Union City, presently the site of a movie studio. (Photograph by Melvin Cheek; courtesy of Geoff Tinsley.)

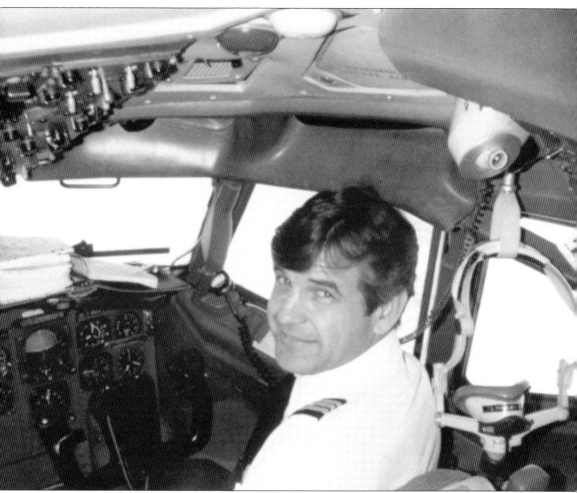

Jerry Tinsley's dream of flying for Delta Airlines was realized on September 4, 1972. He figured Delta's criteria was a Georgia boy with a Georgia Tech degree and a naval background, and he met all the standards required. Tinsley's friend Bob Abernathy flew for Eastern and was an Olympic stunt pilot and outstanding aviation mechanic who built a nice airstrip. Annually, Abernathy held a reunion featuring an air show for Eastern employees on Labor Day weekend. Tinsley was to open the air show with his Stearman biplane, which had just been completely overhauled. Tinsley enjoyed flying small, military planes for stunts and planned to fly a Pitts special during the show. He had performed this maneuver perfectly at practice and just had to do it one more time. However, the second time he did the maneuver, something went wrong, and Tinsley crashed the plane and died on September 3, 1987. The next day, an entourage of Delta pilots presented his wife, Karen, with Tinsley's 15-year pin, even though he was short one day. Tinsley is pictured here in his "office." (Courtesy of Geoff Tinsley.)

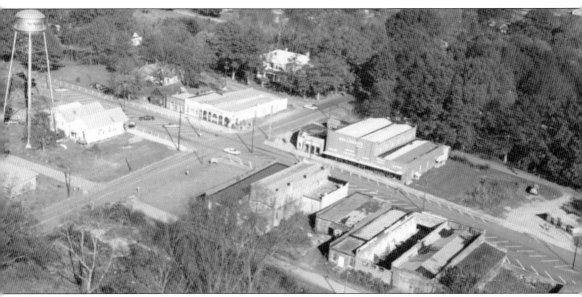

This photograph by Melvin Cheek was taken as his son-in-law Jerry Tinsley flew west in 1977. The long building (bottom center) is the Senoia Buggy Shop Museum. Hollberg's Tire Center is just beyond the Gulf Oil sign in front of Hutchinson's Hardware. R.S. Sewell's station is the small building near the street's end to the right. (Courtesy of Geoff Tinsley.)

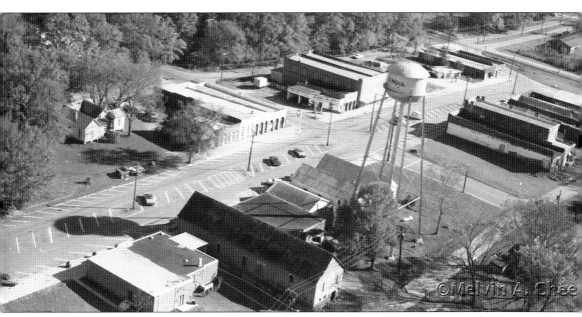

This aerial photograph was taken by Melvin Cheek as Jerry Tinsley flew east over downtown Senoia in 1977. The Hollberg Hotel (currently the Veranda Bed and Breakfast Inn) is nearly covered with trees (top left of photograph). Frank Hollberg had green awnings installed when he began modernizing his family's store. Hollberg razed the dilapidated buildings at far right for new warehouses. (Courtesy of Geoff Tinsley.)

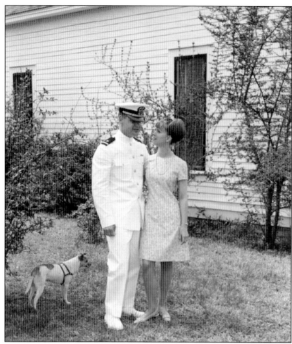

Jerry and Karen Tinsley are pictured at her grandparents' (Edwin and Edna Cheek) home in 1967. Karen's first flight was in an Ironica Champ on her first date with Jerry in 1966. The airstrip they flew from was within the Daniel peach orchard (Big T Airport today). A Navy fighter pilot from 1966 to 1972, Jerry flew an A-4 Skyhawk single-seat fighter jet. (Photograph by Melvin Cheek; courtesy of Geoff Tinsley.)

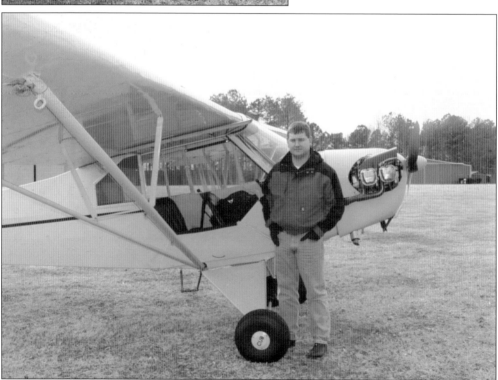

Geoff Tinsley is pictured above with his J-3 Cub. His father, Jerry, was a naval air station flight instructor when his son was born. Geoff spent time in the air on his father's J-3 Cub as a toddler and soloed in it off the strip that became Big T Airport when he was 14. (Courtesy of Geoff Tinsley.)

When Geoff and Angela (Banks) Tinsley's son was born, he was named Jerry Lee Tinsley III after his father and grandfather. His parents affectionately call him "Cub" after the Piper J-3 Cub airplane that has meant so much to the Tinsley family. (Photograph by Angela (Banks) Tinsley.)

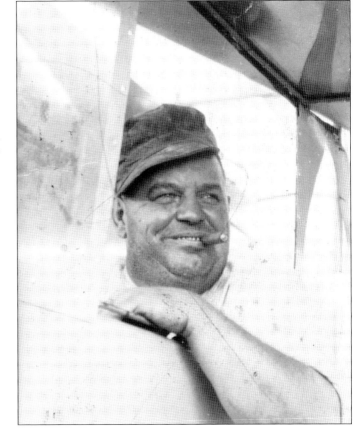

Dock Tinsley was the airplane enthusiast who sparked the Tinsley family's interest in airplanes and mechanics. Tinsley is seen in the cockpit of his airplane. (Courtesy of Gary Welden.)

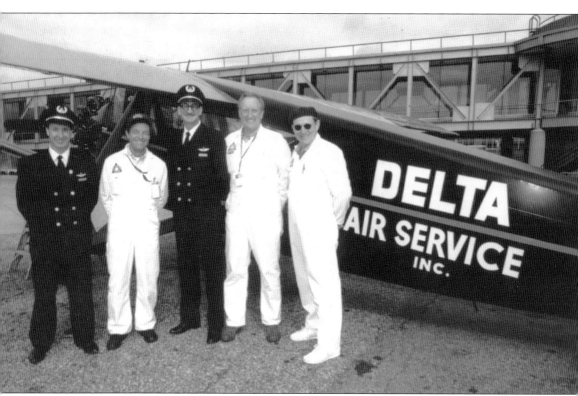

Bill Tinsley received an Allstate motor scooter from his father for his eighth birthday and began taking daring leaps before Evel Knievel was even a public figure. He gained his love of airplanes from his Uncle Jerry, who taught him to fly, and his mechanical ability from working summers with his father and uncle, both of whom were in the grading business. After several years working for Delta in hydraulics, his talents were sought after by James Ray (Delta's manager of restoration and maintenance). Tinsley worked with Ray and a small group of employees to rebuild the 1929 Travel Air (pictured) and later worked to completely rebuild ship 41 (NC28341), the first DC3 put into passenger service by Delta. Tinsley would accompany both airplanes as they were flown around the country, representing significant events and historical routes and offering rides to employees and VIPs. According to Ray, "Bill's ability to transcend different aircraft disciplines made him an invaluable asset to Delta and special aircraft-related projects." Crew members on the Travel Air included, from left to right, unidentified, Bill Tinsley, Robin Maiden, James Ray, and Jeff Houle. (Courtesy of Peggy (Tinsley) Hall.)

As a crop duster who sprayed the Bishop farm, Edgar Todd influenced Roy Bishop to become a pilot when he was a junior in high school and advised that he should ask Ernie Knight at Griffin Flying Services for a job cleaning hangars so he could use his earnings to pay for flying lessons. Bishop was hired and is pictured here working in 1963. (Courtesy of Roy Bishop.)

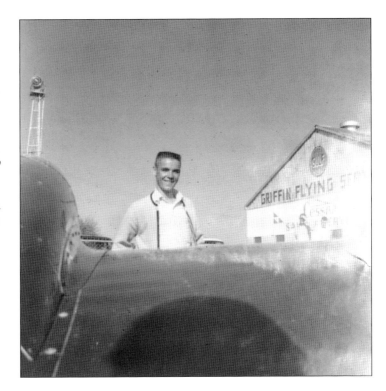

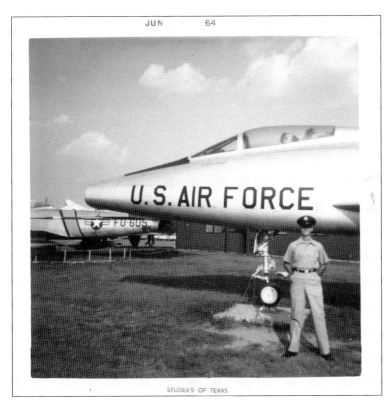

Roy Bishop was new to the Air Force when this photograph taken around 1964. He received civilian flight training in high school, which jump-started his career as a pilot. On the day of his high school graduation, he rented a four-seater plane and buzzed East Coweta High School with his high school buddies on board. (Courtesy of Roy Bishop.)

Roy Bishop returns home from serving the US Air Force in 1968. He served two and a half years in Texas before he was sent to Misawa, Japan. He was discharged at Travis Air Force Base, just outside San Francisco. (Courtesy of Roy Bishop.)

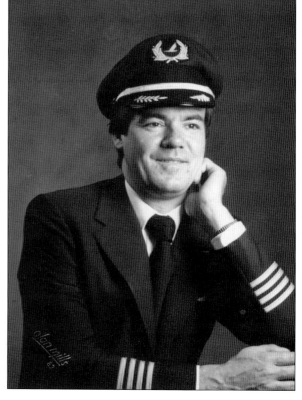

Roy Bishop's career began at Piedmont, which later merged with US Airways, and spanned 37 years, from 1969 until 2006. One of six children born to Hazel and Hayward Bishop, he worked on his family's farm in Senoia from an early age. With regard to flying, he relates, "I always knew there was a better way to make a living than picking cotton in Georgia." (Courtesy of Roy Bishop.)

Four

A TALE OF
TWO RAILROADS

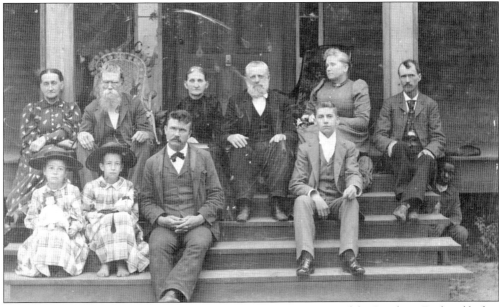

Senoia's first railroad agent, Thomas Newton Vining, was treasurer of the Southern Railroad before moving to Senoia from Macon following the War between the States to help extend the Central of Georgia rail line from Griffin. This 1888 family portrait was made shortly before moving to East Point, where he died. The house where this photograph was made stood across the street from the present-day Senoia Area Historical Society Museum. Pictured are, from left to right, (first row) five-year old Mary Sutton and seven-year old Rix Sutton, daughters of Georgia (Vining) Sutton and granddaughters of Thomas and Leacy Vining; the girls' uncle DeQuincey Vining; and Elam Culpepper; (second row) Leacy (Brown) Vining, Thomas Newton Vining, Mauly and Elam Deracker; and Callie (Carlton) and Sam Thurmond. Kneeling at far right is a small, unidentified boy who surely had stories to tell. (Courtesy of Barbara (McDaniel) Ray.)

An accomplished woman, Estelle Vining (pictured here at age 17 in 1881) studied telegraphy, later teaching the subject at the Georgia Telegraph and Railroad Business College housed above Hollberg's store on Main Street. In 1907, classes ceased in Senoia when the school merged with the Southern Telegraph & Railway Accounting Institute housed on the upper floor of the Reese Opera House in downtown Newnan. (Courtesy of Barbara (McDaniel) Ray.)

In 1871, Willis Sidney Travis and his family moved to Senoia from Spalding County. He met Estelle Vining at the Brantly Institute, and the couple (shown here in their wedding portrait) married following his railroad studies in Wisconsin. Travis became the second Central of Georgia Railroad agent in the family, following after T.N. Vining. The telegraph wire was the only means of communication when Travis served as agent. (Courtesy of Barbara (McDaniel) Ray.)

In 1908, Willis Sidney Travis built this house on Bridge Street for his family after his wife, Estelle, showed him a copy of *Ladies Home Journal*, in which the house was featured. Pictured here in 1918 are, from left to right, (first row) Charlie Homer, Estelle, and Willis Travis; (second row) Frances and Willis Stone "Handsome Jack" Travis. (Courtesy of Barbara (McDaniel) Ray.)

Olin Black McDaniel rented a room at Molly Sibley's boardinghouse on Bridge Street. Crossing over this bridge on his daily walk, he would pass by the Travis home, and the inclination for Susie Travis to sweep the front steps coincided with his ritual. In her early days of driving, Eleanor Cooper likened driving over the bumpy, wooden bridge to the sound of an old roller coaster. The bridge was part of a memorable scene in *Fried Green Tomatoes*. (Artwork by Nancy McConeghy.)

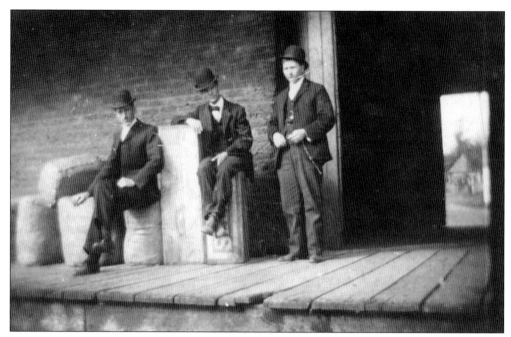

This 1912 photograph of Senoia's Central of Georgia Depot shows Olin Black McDaniel standing at far right. McDaniel moved from the Rock (Upson County) around 1900 to study telegraphy at the Georgia Telegraph and Railroad Business College (above Hollberg's on Main Street) and find railroad employment. When McDaniel married Susie Travis, he became the third Senoia railroad agent in the family. (Courtesy of Barbara (McDaniel) Ray.)

Expectant mother Susie (Travis) McDaniel stands in front of the Vining/Travis/ McDaniel house. In 1911, Susie wed Olin Black McDaniel in the parlor of this home. Her granddaughter Barbara and Barbara's husband, Dale, renewed their vows on the same spot for their 50th wedding anniversary. (Courtesy of Barbara (McDaniel) Ray.)

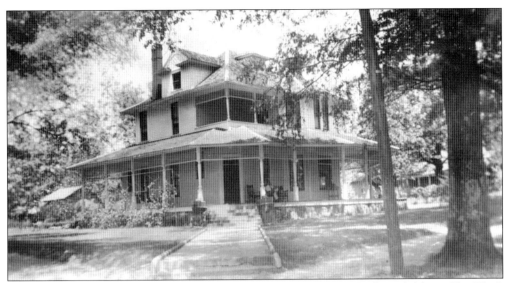

When Willis and Estelle (Vining) Travis moved here in 1908, they had six children. Olin Black and Susie (Travis) McDaniel raised their children in the house, and it was the residence of Susie's sister Frances into her twilight years. Frances gave the home to her nephew Olin McDaniel and his wife, Sue, who lived there for the rest of their lives. McDaniel family members still reside in the house today. (Courtesy of Barbara (McDaniel) Ray.)

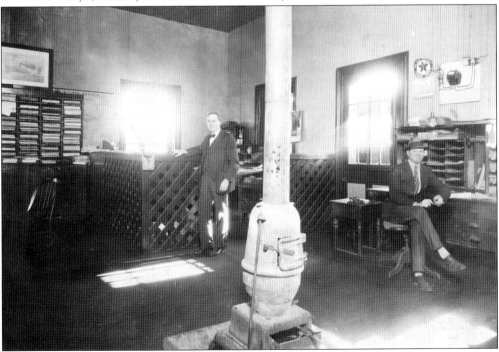

Olin Black McDaniel served Central of Georgia Railroad as agent/telegraph operator, keeping up with the news and cotton prices for 31 years (1920–1951) when the railway had freight and passenger services. He is standing in this 1928 photograph taken at the Newnan railroad office. Walker E. Horne, who served 30 years as clerk for the Central of Georgia Depot, is seated at right. (Courtesy of Barbara (McDaniel) Ray.)

At one time, 12 trains passed through Senoia daily. Belle (Brantly) Jones, mother of Grace (Jones) Tribble, loved to shop and routinely took the early train from Senoia to Union Station in Atlanta, sleeping on a bench until Rich's opened. After shopping all day, she took the afternoon train home. Belle Jones served as the pianist/organist for Senoia Baptist Church and taught piano lessons at the Brantly Institute. Senoia residents James Barnette Sr., Jim Baggarly Jr., and Catherine Brown were some of her students. (Courtesy of Randy Todd.)

Joyce (Cleveland) Smith saved this ticket from a trip to visit her grandmother. She recalls seeing Kathleen Hutchinson who regularly visited relatives via the railway. Smith's father, C.H. Cleveland, was once a Central of Georgia railroad agent. (Courtesy of Joyce (Cleveland) Smith.)

CENTRAL OF GEORGIA RY. CO.
M. P. CALLAWAY, Trustee

SENOIA, Ga. to

NEWNAN, Ga.

7013

GOOD ONLY IN COACHES for one passage within thirty (30) days in addition to date of sale stamped on back, and only on train stopping at these stations.
Subject to tariff regulations.

Cleveland family members pictured here in the 1940s are, from left to right, (first row) Dovie, Joyce, Jane, C.H., and Libby; (second row) Jay. Joyce recalls dances at home, Hollberg's Drug Store curb service, and bowling at a four-lane alley at the corner of Seavy and Main Streets and wearing a green and white bowling uniform. Downtown merchants threw turkeys off the roof at Thanksgiving, and a $10 bill sat atop a greased pole people climbed to try and get the money. (Courtesy of Joyce (Cleveland) Smith.)

Joyce Cleveland was photographed with her brother Harry Cleveland in the 1940s. Joyce and her husband, Bill Smith, purchased the home Burket "Buck" Atkinson built in 1857 (known as Six Oaks) from Carilou Goldberg (wife of attorney Meyer Goldberg). Dr. Franklin M. Brantly delivered 10 Atkinson children and cared for Buck's grandson Hubert in 1898 when he had typhoid fever. Meyer Goldberg was the special prosecutor for the infamous John Wallace murder trial surrounding the murder in Coweta County in 1948. (Courtesy of Joyce (Cleveland) Smith.)

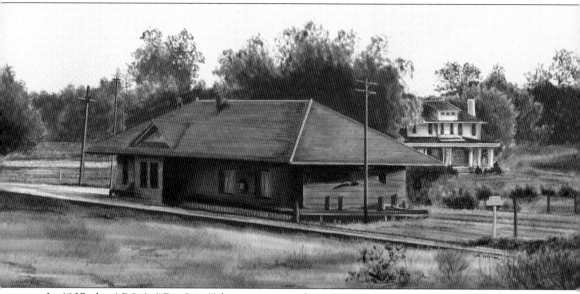

In 1907, the AB&A ("Bee Line") began running from Birmingham to Atlanta, along the coast of Georgia, and through Senoia. At that time, large, wooden water towers near the depot held water for train boilers to keep steam engines going. Sometimes, Walter and Warren Baggarly swam atop the towers on summer afternoons with their friend Frank Harris. Carloads of peaches were packed and shipped from Senoia's numerous peach orchards, and Benton Gill, who rented an apartment at the Lee and Lizzie Hutchinson house (shown at right) across from the depot, got up at all hours of the night to unload oil tanks from the train for the Hutchinson's Standard Oil franchise. Together, the Central of Georgia and AB&A rail lines had four passenger trains that ran from Savannah through Griffin and from Senoia to Chattanooga. Frank "Buddy" Hollberg recalled riding the train as a child to Atlanta and back with his friend Jim Baggarly Jr. to see three movies and visit the trick novelty store—all for the grand total of $1. This depiction of the train depot and Hutchinson house was made before the Langford/Atkinson/Moye home was built. When David and Rhonda Moye occupied the former property of William H. Langford (who was the original manufacturer of horse collars in Senoia), they discovered metal parts from horse collars all over the yard. The Moyes' son Zack made sculptures out of "found objects," and several of his creations included horse collar implements. (Artwork by Melissa (Dieckmann) Overton.)

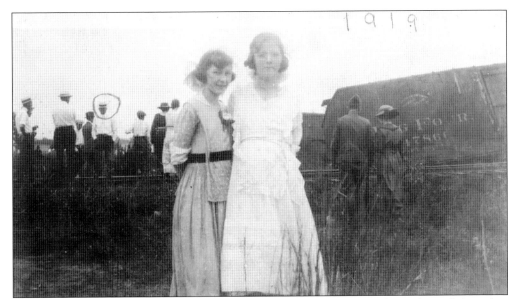

Senoia resident Frances Travis is pictured at right (others unidentified) at what is believed to be an AB&A train wreck in 1919. Research results did not reveal a Senoia train wreck in 1919; however, it is interesting to note that Frances Travis did not have a car and would likely have walked to where this photograph was taken. She noted "1919" on this photograph in her personal scrapbook. (Courtesy of Barbara (McDaniel) Ray.)

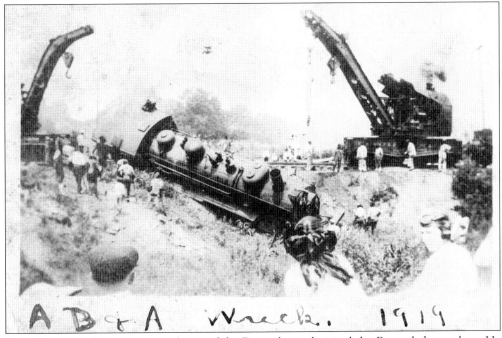

James Harrison Claxton was a relative of the Baggarlys and visited the Baggarly homeplace. He noted, "A.B.&A. train wreck, 1919," on this photograph in his personal scrapbook. A 1919 train wreck could not be found in AB&A's historical records, but records were not meticulously kept at the time. It is noteworthy that two people in Senoia would have a photograph of a train wreck in 1919. (Courtesy of Scott Baggarly and the Senoia Buggy Shop Museum.)

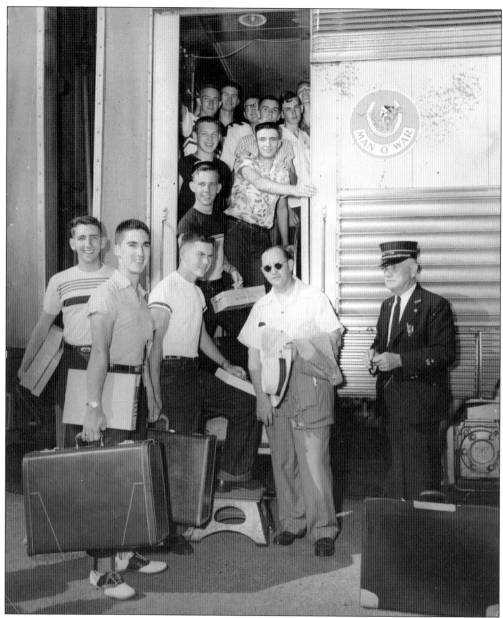

In this 1951 image of a Key Club trip, passengers on the "Man O' War" included, from left to right (first row) Frank "Buddy" Hollberg, Jim Baggarly Jr., Bitsy Lucas, Cauley Hayes, and an unidentified conductor; (second row) Sam Crain; (third row) Alton McKinley and Henry Drake; (fourth row) two unidentified, Frank Daniel, Pooley Davis, and two unidentified. The Key Club is an international program led by high school students. Founded in 1925, its goal is to encourage leadership by serving others. The Key Club is part of Kiwanis International, and high school clubs are sponsored by local Kiwanis. Frank Hollberg took over Hollberg's Furniture Store following the death of his father. Jim Baggarly Jr. had a career at Bearings and Drives. Cauley Hayes opened a men's clothing store on the Newnan court square. Frank Daniel owned a lot of property, gave lavish parties, played the piano for Senoia United Methodist Church, and was known as "Diamond Daddy" because of the large diamond ring he wore. (Courtesy of Tray Baggarly.)

Five

HEROES AND LOCAL LEGENDS

Stories about Walter and Warren Baggarly are legendary. As teenagers, they made a dummy, poured ketchup over it, tied it with string, and hid it to see what would happen next. The grisly dummy drew a crowd, and Senoia policeman Carl Drake came to see what was happening. "Give him some air," he told the crowd just as the twins pulled the string and the dummy shot back across the street. As an adult, Walter had a pet lion he walked downtown on a leash. Olin McDaniel Jr. rode to school with the twins. He relates, "They lived a Huck Finn kind of life, and I was fascinated by them. During chapel in the 1950s, a curtain opened to reveal Walter on stage playing *Great Balls of Fire* like Jerry Lee Lewis. It was a fantastic performance, and everybody went wild!" Janet Baggarly relates that her husband could play any instrument. In this photograph, Walter plays the piano at the Senoia Buggy Shop Museum, which he created for the Senoia community to preserve its rich history. (Courtesy of Janet Baggarly.)

The eldest child of Edwin and Edna Cheek, Melvin Cheek (right) was Senoia's first photographer. He became interested in photography while serving under the command of General Eisenhower in Germany. His daughter Karen recalls, "Everywhere we went, the camera went. Daddy built a darkroom at my grandparents' house. I remember him saying, 'Come in here, and let me show you how to develop these pictures.' We stood in awe as images came through on the paper. It seemed like a magic trick. Daddy photographed us everywhere; at the Liberty Bell pool, at Callaway Gardens, with the McKnight family . . . I remember Aunt Rosie wearing a red dress to Grant Park back when everybody dressed up to go to Atlanta. Daddy photographed us all in color at the zoo. It took him 15 minutes sometimes to make one photograph, getting everything just right on the tripod. If the church, Lions Club, or Masonic Lodge was having something, Daddy took pictures. Senoia events were documented because of Daddy's passion." (Courtesy of Geoff Tinsley.)

William Tinsley (also known as "Wiewie") was a hardworking man. The father of Bill, Peggy, and Bob, he was a World War II veteran. Tinsley had a woman tattooed on his leg and loved to flex his calf muscle, laughing out loud while making her dance. Following service on the USS *Eberle*, Tinsley started building small ponds and ended up handling all the grading for North Dekalb and Southlake Malls. (Courtesy of Peggy (Tinsley) Hall.)

When Joyce Tinsley (right) became ill, William Tinsley (left) quit work to care for her. When she improved, he began working in the pulpwood business, and Joyce lived 12 more years. Years later, William married Martha, who became a special part of the Tinsley family. All have since gone to their heavenly reward. William loved to laugh and camp and was always "in the road" going somewhere. (Courtesy of Peggy (Tinsley) Hall.)

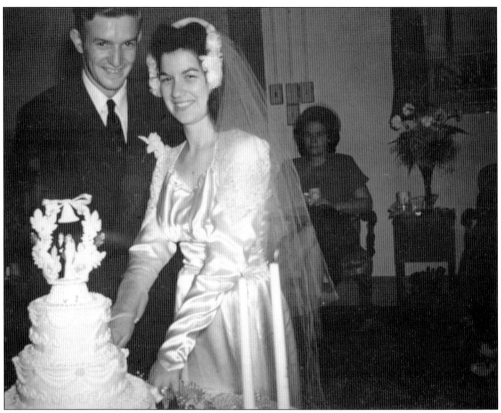

Paul and Totsie (Carrasco) McKnight married in 1948. They raised six children: Ray, Carl, Alice, Margaret, JoAnn, and Jim. Paul served 10-plus years on Senoia City Council, helped establish St. Mary Magdalene Catholic Church, and was chairman of Coweta's board of education 30 out of 31 years. A founding member of the Variety Club and St. George and St. Mary Magdalene Catholic Churches, Totsie chaired the Senoia Area Library Board. (Courtesy of Totsie McKnight.)

Ellis Crook picked cotton and worked in a brickyard and a peach factory before opening Senoia's first supermarket, Crook's Marketplace. He was married to Pat Crook for nearly 57 years. Pat held degrees from Auburn University and was a teacher at East Coweta School and one of the founders of the *Taste of Georgia* cookbook. This photograph was made at the Georgia Retail Food Dealers Convention in Atlanta. (Courtesy of Patricia (Yarbrough) Crook.)

During World War II, Olin McDaniel served under General McArthur as an Army ordinance officer. When the Korean War broke out in 1950, McDaniel and his wife, Sue, were aboard a battleship zigzagging across the Pacific in the dark to avoid being hit by a submarine. McDaniel was later assigned to a secret military test facility in White Sands Proving Ground, New Mexico, working with atomic warheads in 1953. (Courtesy of Barbara (McDaniel) Ray.)

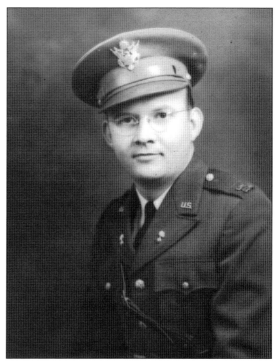

Prior to retirement in 1957, Olin McDaniel's aunt, Frances Travis, offered him the Travis family homeplace. Thus, McDaniel and his wife, Sue, moved to Senoia, where Olin continued to put his Georgia Tech degree to good use in his second career as a high school math teacher. Together, the McDaniels enjoyed fishing, gardening, golfing, and family time. Olin is depicted here at his home in the 1970s. (Courtesy of Barbara (McDaniel) Ray.)

Robert Wilkerson began his career in Senoia as a substitute teacher during segregation. He later became a primary fifth-grade teacher in a self-contained classroom where he taught all subjects. Husband to Rosa and father of Emory and Calystia, he became principal of Eastside Elementary School in 1967. As principal, Wilkerson handled banking transactions at Farmers & Merchants Bank downtown. Although he was not a Senoia resident, he was a familiar face around town, and local merchants knew and respected him. When the time came to integrate schools, Supt. Robert E. Lee met with Wilkerson, teachers, and other county leaders for over a year to discuss the best way to effectively integrate schools. The superintendent used a plan formulated by the University of Georgia as his blueprint for success, and Caucasian students were fully integrated into Eastside Elementary (formerly an African American school) by 1972. Robert Wilkerson served as principal until 1985, when he was transferred to the central office and given the responsibility of overseeing educational testing for the Coweta County school system. (Courtesy of Robert Wilkerson.)

The "Goat Man" (Charles "Ches" McCartney) visited Senoia for 40-plus years, traveling in an iron-wheeled cart pulled by goats. Along the way, he collected donations for the Free Thinking Christian Mission and sold postcards of himself with his goats. Reportedly, he stunk to high heaven, but people were always excited to see him. He is pictured with Beth and Jim Hutchinson. (Courtesy of Jane (Hutchinson) Arnold.)

Sgt. Robert Edward Couch served in the US Army and is remembered on Panel 35W, Line 8 on the Vietnam Wall. His friends fondly remember him as "Eddy." The son of Vance and Elna Couch, he was killed in the Thua-Thien province of Vietnam on December 30, 1968. A bridge in Senoia has been named in his honor. (Courtesy of Betty (Cookman) Armstrong.)

Betty Cookman became an Eastern Airlines flight attendant in 1961 following graduation from the University of Alabama. At flight school, she learned her hair could not touch her collar, and if she gained more than five pounds, she would be grounded until she lost weight. Ladies who married resigned as flight attendants and accepted a position on the ground. A bride in 1963, Cookman was assigned to lost and found. She loved having her own office, and she enjoyed the challenge of finding lost luggage. The mother of Christopher Jordan Cookman, she moved to Senoia in 1969 and soon became involved in the community and Senoia United Methodist Church, where she played the piano for a decade before lending her musical talent to Senoia First Baptist Church for six years. She served as Senoia city clerk for nine years and spearheaded the effort to develop the Senoia Area Library with Jack Humphrey. Cookman is a talented genealogist and provided historical information regarding the Baggarly family and the Senoia Area Library for this book. (Courtesy of Betty (Cookman) Armstrong.)

Marvin "Lefty" Duke departed Georgia Tech his freshmen year to play career ball with the Atlanta Crackers in 1929. A scout for the New York Yankees spotted his pitching and signed him to play ball for the Yankee minor leagues in 1930. The Senoia High School graduate had the biggest year of his career in 1932, winning 16 straight games in a row and ending with 23 wins for the season. Fellow southpaw Babe Ruth showed up for a game but did not expect to play because the team's position was secure for the World Series. When the coach told Babe to play, he did not have a glove, so he borrowed one from Duke. The Senoia lefty's pitching arm was credited with leading the Central League that year. He played the largest part of his career with the Yankees but was purchased for a substantial figure by the Pittsburgh Pirates in 1937. He tied for most wins in the International League while playing for the Pirates and struck out former Yankee teammate Lou Gehrig. (Courtesy of Aimee Duke.)

Georgia's youngest mayor (at age 25), Jimmy Hutchinson served the Senoia Downtown Development Authority and chaired the Senoia United Methodist Church board. His widow, Jane (Hutchinson) Arnold, is past president of the Variety Club/ Senoia Area Business Association and a sustaining member of Junior Service League, where she tested recipes for the *Taste of Georgia* cookbook. A great resource and an avid salesperson, Jimmy jokingly told friends not to let Jane pass out catalogs at his funeral. (Courtesy of Jane (Hutchinson) Arnold.)

Methodist minister James L. Welden pastored several Georgia churches: Red Oak/Atlanta, Oak Grove/Decatur, Jonesboro First United Methodist Church (FUMC), Parks Street/Atlanta, Monroe FUMC, Bethany/Smyrna, and finally Clarkston FUMC. His son Gary was six years old when the Ku Klux Klan (KKK) burned a 10-foot cross in front of the Welden home in Decatur. At the onset of integration, the University of Georgia (UGA) was an all-white school and made an attempt to stay segregated by requiring that all applications for admission include a character reference from an alumnus. A UGA graduate, Welden signed a character reference for two African American students (Charlayne Hunter and Hamilton Holmes). Hunter became an award-winning journalist and author, and Holmes became the first African American accepted to Emory University's School of Medicine. The KKK followed Reverend Welden from church to church during his ministry, burning another cross in the yard of his Jonesboro home in the early 1960s and plastering cars and mailboxes in the Parks Street Methodist parking lot and neighborhood with a racist poem threatening the Welden family. Welden remained true to his convictions. (Courtesy of Gary Welden.)

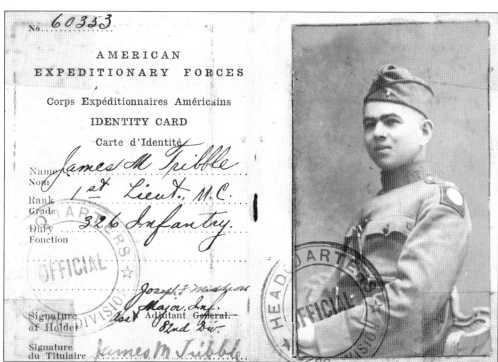

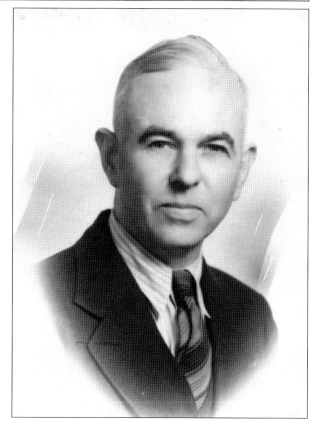

Dr. James Mercer Tribble delivered 1,000-plus babies during 50 years of practice in Senoia. His twinkling blue eyes, sharp wit, and the smell of his cigar stub are etched in the minds of many. He arrived in town by train in 1915 with 14¢, a derby hat, and a tin-topped trunk. Following service with a World War I ambulance unit, he married Grace Jones and fathered Charlotte and Mary Brantly. (Courtesy of Randy Todd.)

Dr. Tribble served as the first Army colonel from Coweta County during World War II. He was Senoia mayor for 15 years, installing a water system and sidewalks. Ronnie Glazier has a clear memory of Dr. Tribble's preference for a shot of penicillin as a cure for most ailments. On the 50th anniversary of his medical practice, 300 people gathered for a celebration at East Coweta School. (Courtesy of Bill Todd.)

Charles Frank Hollberg III (pictured at left with former president Jimmy Carter when they were Lions Club district governors and his father, Frank Jr.) was known as "Buddy" before his father died. A 1952 Newnan High School graduate and Eagle Scout, Hollberg III enjoyed playing the trombone, which hung on his office wall. He chuckled while reminiscing on being a musician, noting a desire to play football and sharing that the coach said the band needed him much more than the football team. Hollberg III occasionally accompanied his mother, Virginia, when she played piano for Senoia Baptist Church. A Georgia Tech graduate, he began serving the Navy in 1956, retiring as a naval reserve captain. He and his wife, Sandra, had three children, John, Louise, and Catherine. The proprietor of Hollberg's Furniture, he influenced the development of the Peach Bowl, was active in Senoia and Georgia Lions Clubs and Senoia Downtown Development Authority, and served on the boards of the Heritage School and Coweta Community Foundation. In 2002, he married Bonne "Blue" Eppinette, and they enjoyed their lives together until Frank's death in 2017. (Courtesy of Frank Hollberg.)

Six

CHURCH, SCOUTING, AND SPORTS

Senoia United Methodist Church's JOY (Jesus/Others/Yourself) Sunday school class members included, from left to right, (first row) Ben Haisten, Frances Cleveland, unidentified, Edith Sewell, Hattie Shell Whatley, and Catherine Awtry; (second row) Bennis Duke, Pat Crook, Edith Morgan, Phyllis Crook, Harold Awtry, and Montine Caldwell; (third row) Marvin Duke, Glenn Cole, Ellis Crook, Hugh Crook, David Christian, and Elbert Caldwell; (fourth row) Ray Sewell, Rev. Don Welch, Ed Terry, Sue Williams, Andy Nations, and Aubrey Crook. (Photograph by Melvin Cheek; courtesy of Geoff Tinsley.)

Established as the Methodist Episcopal Church South (Senoia's first church) by Rev. Francis Warren Baggarly, members first met in a brush arbor prior to construction of the Rock House. Depicted from left to right are teenagers Robin (Reese) Ray, Kim (Adcock) Smith, Beth (Hutchinson) Tripp, Daniel Ridenhour, and teacher Jeanne Fleet at the Senoia United Methodist Church youth Sunday school class in the 1970s. (Photograph by Melvin Cheek; courtesy of Geoff Tinsley.)

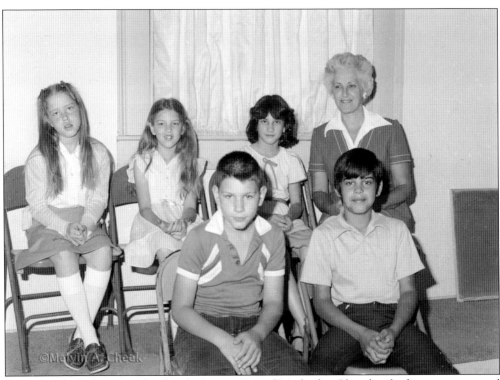

John Mays built the original pulpit for Senoia United Methodist Church, which was constructed in 1898. Georgia notes Senoia United Methodist Church's building as the finest example of Queen Anne–style church architecture in the state. Students pictured are, from left to right, (first row) Chuck Kurz and Peter Cabrera; (second row) Michelle Morgan, Paige Myracle, unidentified, and teacher Beth West. (Photograph by Melvin Cheek; courtesy of Geoff Tinsley.)

Pictured in this 1970s Senoia United Methodist Church Sunday school photograph are, from left to right, (first row) Sandy Campbell and Laura Gable; (second row) Glenn Wieringa and Beria Orr; (third row) Jim Reese and Scott Kurz. Teacher Sue Farr is standing at the back of the table. (Photograph by Melvin Cheek; courtesy of Geoff Tinsley.)

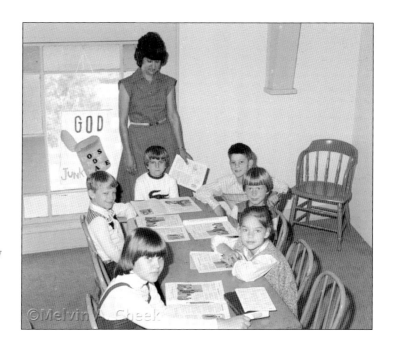

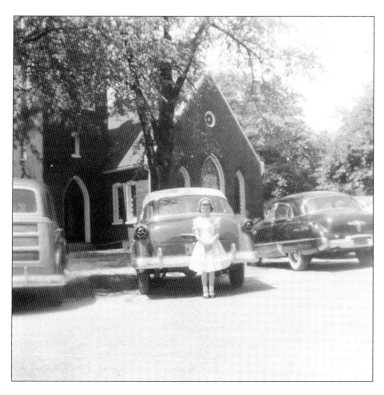

In 1867, the Baptist Church of Christ at Senoia, Georgia, was established, with Henry S. Rees as pastor. Pastor Rees was ordained in 1853 and ministered for 70-plus years, composing 14 sacred harp songs (a style of a capella sacred, choral music), which he taught. The church became Senoia Baptist Church in 1881 and later First Baptist Church of Senoia. Judy Cooper stands in front of the church in the 1950s. (Courtesy of Eleanor Cooper.)

Mary Brantly Tribble is seen at Senoia Baptist Church on graduation day in the 1940s. James Barnette Sr. sang tenor in the choir with Tribble in the 1970s. Martha Gill taught Sunday school there in 1944, continuing for 60 years. She and her husband, Benton, were church historians. Benton was church clerk for 25 years, and Martha was treasurer and financial secretary for 17 years. When Benton died, Martha wrote the church history and gave copies to members and friends in his memory. (Courtesy of Randy Todd.)

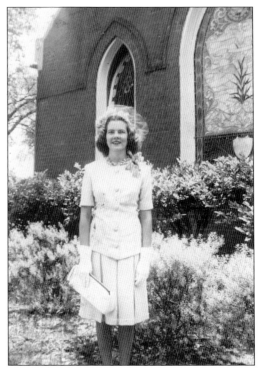

Estelle and Willis Travis carry the family Bible on their walk to Senoia Baptist Church in 1920. Estelle's father, T.N. Vining, was a deacon at the church when it was newly established in 1871. Estelle and her friend Annie (McLane) Davis are remembered as working hard for the benefit of the church by hand-sewing communion cloths, selling handwork, and organizing bazaars to raise funds. (Courtesy of Barbara (McDaniel) Ray.)

Oak Grove Baptist Church at 41 Seavy Street has ministered to the Senoia community for more than 100 years. Annie (Maynard) Alexander remembers attending church there with her parents, Eddie B. "Cobe" and Kate (Moore) Maynard, her grandmother Annie Moore, and her five brothers and five sisters. The Maynard family was well known in town. Annie's father worked for the Atlantic Coastline Railroad, fixing the rails and cleaning up after train wrecks while her mother, Kate, worked at the Senoia Café restaurant in downtown Senoia. Annie recalls her mother making hominy, sauerkraut, and watermelon rind preserves; drying apples and peaches; canning blackberries; and making jam. In later years, Annie and her siblings would sometimes go to the Senoia Theater to watch a movie. She notes, "During intermission, we would run quickly down to Addy's store to get a hot dog and take it back to eat while watching the rest of the movie." Her sister Eddie Kate cared for Hal and Elaine Sewell while their parents ran their business, R.S. Sewell Merchandise, on Main Street. Eddie Kate Maynard is memorialized with a brick donated by Hal and Vicki Sewell on the Senoia Area Historical Society Museum walkway. Annie remembers Rev. W. Tucker as a long-standing preacher at Oak Grove Baptist Church. The reverend baptized her when she was 14 years old and officiated her wedding to Albert Alexander 61 years ago. Bishop Milton Holston and his wife, Earnestine (pictured above), and the body of believers at Oak Grove work together today to communicate the life-changing power of Jesus Christ in a practical and understanding way. (Photograph by Carla (Cook) Smith.)

Lynn Brown presents a trophy to 11-year-old Girl Scout Beth Hutchinson in 1975. According to her mother, Jane Hutchinson, Beth sold the most cookies in Senoia, Coweta County, and the district. Her father, Jimmy Hutchinson, and family friend Jo Morgan helped Beth deliver her cookies when they came in as her mother's car had just been hit by a train. Fortunately, Jane lived to tell the tale. (Courtesy of Jane (Hutchinson) Arnold.)

Cub Scout Brantly Todd practices his salute. Beverly Bishop worked with the Cub Scouts, and her husband, Vernon, assisted Billy Adcock with the Boy Scouts. According to Beverly, the Cub Scouts met at the Bishop house, and the Boy Scouts met at Senoia Area State Park or in Jim Baggarly Sr.'s garage. (Courtesy of Randy Todd.)

Following service to the US Marine Corps, Billy Adcock worked at the Hapeville Ford plant for 30 years. He met J.T. and Frances Pollard's daughter Dianne (the first Miss Senoia) at the gas station/grocery store her father owned on Highway 16. He became Scoutmaster for the Boy Scouts of Senoia in 1967, and in 1977, he received the Scouting Distinguished Service Award. Two years later, Adcock received the highest honor given to an adult by the Council for Boy Scouts when he was decorated with the Silver Beaver Award for Distinguished Service to Boyhood. Adcock signed on as president for the East Coweta Little League in 1978, a position he held for 14 years. He received the East Coweta Little League and Community Award in 1984 for his "untiring dedication to the youth of his community." In 1997, he was honored with a lifetime membership in the Senoia Area Athletic Association for his unselfish commitment to all players on the field. Billy and Dianne Adcock are the parents of Kim Adcock Smith, the wife of race car driver Clint Smith. (Courtesy of Dianne (Pollard) Adcock.)

Senoia Boy Scout Troup No. 42 tries out its mess kits around the campfire. Pictured are, from left to right, three unidentified, Chris Toles (wearing a University of Georgia hat and looking over Leigh's shoulder), Leigh Morgan (holding a pan looking at his dinner), Keith Burks (wearing Packers shirt), Jeff Bishop (kneeling), and Rory Thompson looking at Jeff's shoes (or perhaps a lizard). (Courtesy of Jeff Bishop.)

Jeff Bishop and friends contemplate the best way to put up their tent on a camping trip with Troop No. 42 in February 1981 at McKnight Lake. Bishop recalls that all the eggs and milk froze and that he had to sleep atop a tree root. Bishop's dad, assistant Scoutmaster Vernon Bishop, toughed it out in the back of the van pictured here. (Courtesy of Jeff Bishop.)

Pictured are, from left to right, Senoia Boy Scouts Rory Thompson, unidentified, Keith Burks, unidentified, Leigh Morgan, unidentified, Chris Toles, and Jeff Bishop. Rory Thompson, David Smith, and Rusty Kitchens were also on the trip. The boys all attended East Coweta Middle School and enjoyed camping, snipe hunting, and fishing. One camp dinner was hamburger meat and onions wrapped in foil and placed directly on the fire. (Courtesy of Jeff Bishop.)

Vernon Bishop (seen here with son Jeff) assisted Scoutmaster Billy Adcock with Boy Scout Troup No. 42 for many years. The Scouts often camped at McKnight Lake across from Eastside School. On one trip, a contest was held to see who could catch the biggest fish. Jeff won and still has the knife he received as a prize. (Courtesy of Jeff Bishop.)

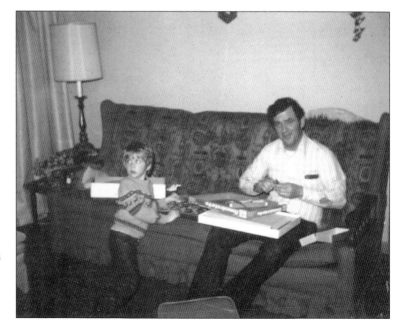

Chris Hanson, No. 2 holder and punter for the Jacksonville Jaguars, gives a thumbs up to Carl McKnight before a game against the Atlanta Falcons. Schoolmate Keith Brooking was sidelined by the Falcons for that game due to an injury. Fellow East Coweta graduate Christopher Lamont Young (who could not be reached for comment or photograph) played for the NFL as a safety for the Denver Broncos and is ranked 10th among all-time Georgia Tech defensive backs. He was also a team captain. (Photograph by Carl McKnight.)

The Atlanta Falcons built its defensive strategy around linebacker Keith Brooking (No. 56) in his rookie season. During that time, he had 32 tackles in 15 games, recording 8 tackles in the NFC Championship game against the Minnesota Vikings. In this photograph taken during Super Bowl XXXIII, Brooking played for the Falcons against the Denver Broncos. (Photograph by Carl McKnight; courtesy of the *Coweta Journal*.)

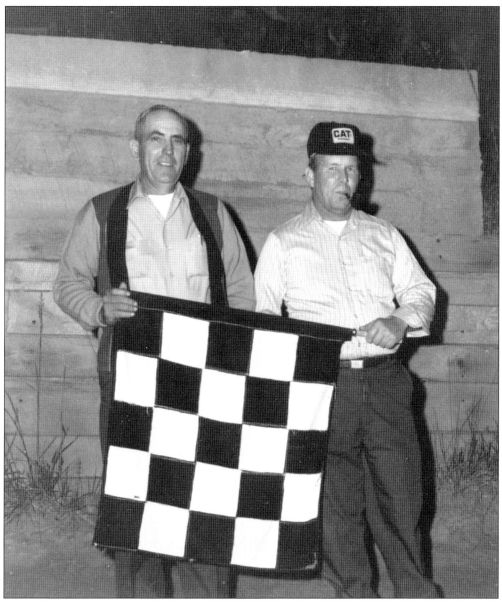

Partners Hence Pollard (left) and David Bishop (right) hold the checkered flag at Senoia Raceway, which opened on March 16, 1969. A true race fan, Pollard and his family regularly attended Newnan's dirt track races, which is where he first entertained the idea of building a track of his own. Bishop was a grading contractor, and Pollard was a logger at the time they built the three-eighth-mile oval dirt track (recently touted by *Dirt on Dirt* magazine as one of the top 10 dirt tracks in the United States). Bishop later pursued other interests, and Pollard ran the track as the family business with his wife, Reba, running the concession stand; his son Sonny watering the track; daughter Becky scoring the races; and Billy Whitlock, Reba's brother, working as a track official. Sonny's car "Ole Betsy Blue" won 18 out of 20 races during the 1997 season. Hence's grandson Bubba Pollard is noted as one of the "top short-track asphalt race drivers in America." Rick Minter received season passes annually from Hence Pollard and did his best to promote the raceway to repay the kindness. (Courtesy of the Pollard family and the Senoia Area Historical Society.)

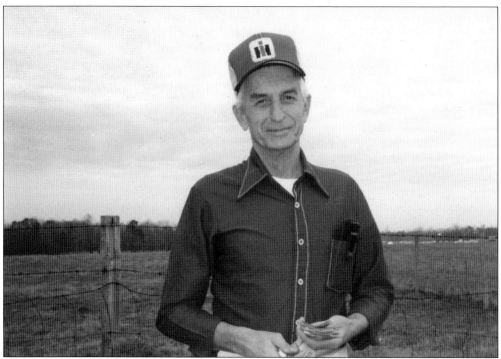

Early Senoia Raceway fans will likely remember Eugene Hubbard, who sold tickets at the gate for many years. Reba Pollard ran the concession stand, and Buford "Blue" Shelton cooked the barbeque with Billy Adcock on race days. Charles Edward purchased the track after Hence Pollard died and ran it for several years before it came under the control of Bill Massey and Doug Stephens. Massey was a track promoter under both Hence Pollard and Charlie Edwards. (Courtesy of Judy (Hubbard) Mullis.)

Leon "Slick" Sells won the first late-model (Sportsman) race at Senoia Raceway, driving his No. 77 Camaro on opening day at the track on March 16, 1969. Bob Moore won hobby, and Kenneth Mills took first in amateur that same day. Leon Sells's racing career spanned 40-plus years and earned him a place in both the National Dirt Late Model and Georgia Racing Hall of Fame. (Courtesy of Bill Massey.)

When Mike Bristol started racing, he nurtured a love for the sport in his daughter Marcie (pictured with him in his No. 54 race car). Marcie relates, "On Saturday nights, we loaded Dad's car on a homemade open trailer and headed to Senoia for a chance to take home the checkered flag among the weekend warriors." In 1997, Mike won 7 out of 21 races and the division championship. Marcie notes, "I observed, absorbed and learned throughout the wins and losses, hoping to follow in his footsteps." When Mike stopped racing, he purchased a Bandolero car to get Marcie's feet wet in the sport. She finished fifth in the division championship at Senoia Raceway in her first season, all while juggling high school, softball, and cheerleading. In 2005, Marcie drove her dad's late model in the Iceman Late Model Series (the only female driver), determined to earn the respect of the veterans her father once raced. Her favorite raceway memory is a victory lap around the track, waving the checkered flag in memory of her dad and hero. (Courtesy of Marcie (Bristol) Sims.)

Sonny Pollard (left) sits at the Senoia Raceway with his father, Hence Pollard (right), one of the best promoters in dirt-track racing history. Georgia Racing Hall of Famer Mike Head considers Senoia his home track and remembers Hence helping him with equipment in order to race. Sonny notes, "My Dad was not into racing for the money. He was in it because he was a fan." In January 2021, Sonny purchased the track his father built. (Courtesy of Bill Massey.)

Senoia Raceway has long been a feeder track to NASCAR. Reed Sorenson, Joey Logano, and Mason Massey all got their start in Senoia. Mason Massey, who drives in the Xfinity series for NASCAR, is the grandson of Senoia Raceway promoter Bill Massey and represents the Massey family in 75 years of consecutive racing. (Courtesy of Bill Massey.)

Seven

SWEET MEMORIES AND SPECIAL EVENTS

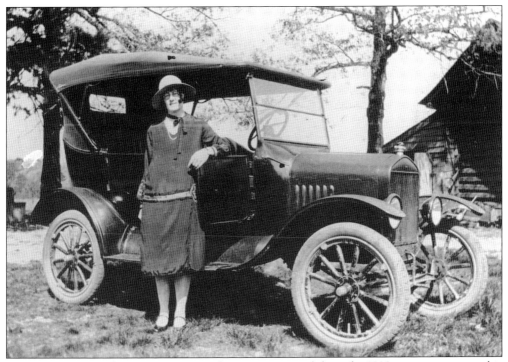

It was not commonplace to see a woman driving an automobile in the 1920s, so it was a pretty big deal when Nellie Addy began driving. She is pictured here with her car at the Addy homeplace at the intersection of Hardy Road and State Route 85, where Hosea Gray and his family later lived. (Courtesy of Janet Baggarly.)

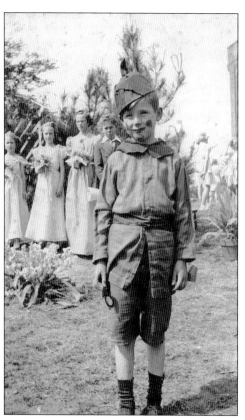

Young Ellis Crook (standing front and center) participated in a May Day festival in Senoia when he was in elementary school. The girls in the back are unidentified. (Courtesy of Ellis and Pat Crook.)

Frank Hollberg (left) and Jim Baggarly Jr. (right) were friends as children and adults. During childhood, they rode their scooters. When they were a little older, they rode their Whizzer bikes together down Main Street along with friends James Barnette Sr. and Jimmy Hutchinson. Barnette and Baggarly would each put a plug of tobacco in their mouths before the ride began. The lead would spit if another rider tried to go around him. Jimmy Hutchinson was the youngest among them, and Frank Hollberg was a year younger than Barnette and Baggarly. The younger boys did not chew tobacco. (Courtesy of Tray Baggarly.)

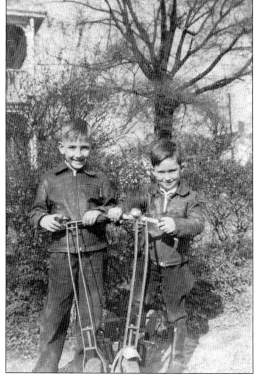

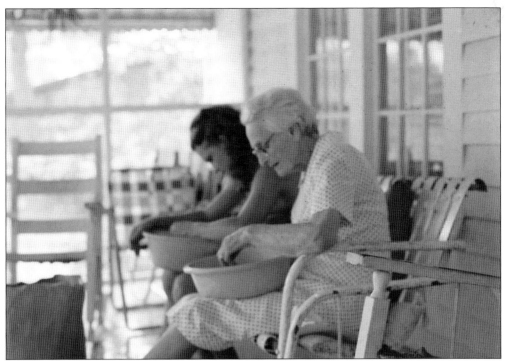

Edna "Gimma" (Summers) Cheek was in her mid-1970s when photographed by her son Melvin popping peas. Karen Tinsley recalls, "Gimma filled her apron with apples from the backyard, sliced and put them on the back porch to dry. Thereafter, she made homemade fried pies in a black iron skillet. When Gimma was making apple pies, you knew it was going to be a good day." (Courtesy of Geoff Tinsley.)

Known for his kindness, Bill Tinsley agreed to help friends with a squirrel problem. When he arrived on the scene, he was found outfitted with an AR-15, a 44 magnum, a bayonet, and a "Squirrel Busters" helmet. Quite the character, he once donned a robe and walked barefoot sporting long hair and a beard into the Senoia United Methodist Church pulpit and recited the "Sermon on the Mount" from memory. (Courtesy of Peggy (Tinsley) Hall.)

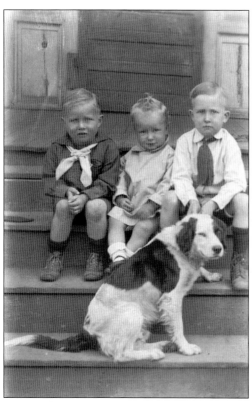

James Lee Welden (right) sits with his siblings Ann Welden Stegall and George L. Welden as well as the family dog around 1921. (Courtesy of Gary Welden.)

Jim Wilkes stops to hold the family dog while looking into the distance. Perhaps there is a rabbit or maybe a quail. Whatever he sees, a smile plays about his lips at the sight of it. (Courtesy of Randy Todd.)

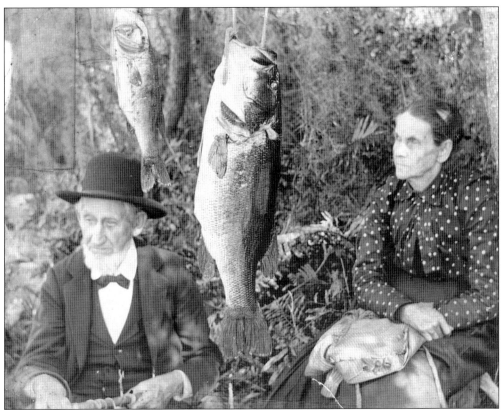

Dr. Franklin M. Brantly and his wife, Margaret Ezzard (Collier) Brantly, enjoyed fishing and were apparently very successful fishermen. The couple's nine children—Dr. A.H. Brantly and John Brantly of Atlanta; Mrs. Frank Forth of Dawson S.B., B.H. and W.B. Brantly of Clermont, Florida; Col. F.M. Brantly of Fort Worth, Texas; and Mrs. S.E. Sibley and Belle Brantly Jones of Senoia—survived them. This image was captured around 1905. (Courtesy of Randy Todd.)

Doc Tribble never let a good cigar go to waste, even when he was fishing, as seen in this 1940s photograph. (Courtesy of Bill Todd.)

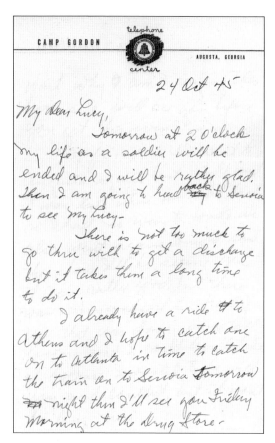

My Dear Lucy,

Tomorrow at 2 o'clock my life as a soldier will be ended and I will be rather glad. Then I am going to head back to Senoia to see my Lucy —

There is not too much to go thru with to get a discharge but it takes them a long time to do it.

I already have a ride to Athens and I hope to catch one on to Atlanta in time to catch the train on to Senoia Tomorrow night then I'll see you Friday morning at the drug store —

James Lee Welden could not wait to get out of the service and home to Senoia and Lucy Tinsley, as evidenced by this letter he wrote to her on October 24, 1945. They were married just 11 days later on November 4, 1945. (Courtesy of Gary Welden.)

Newlyweds James and Lucy (Tinsley) Welden are pictured on their wedding day. Lucy's mother, Margaret Tinsley, is shown in the background. (Courtesy of Brenda and Gary Welden.)

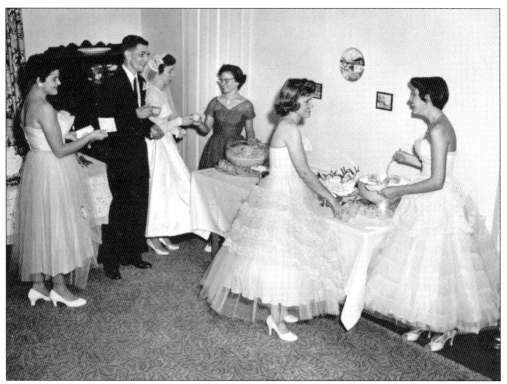

Numerous people from the Senoia community were delighted to attend the wedding of Catherine and James Barnette at Senoia Baptist Church. Pictured at the reception are, from left to right, Mary Ann (Parks) Reese, James Barnette, Catherine (Brown) Barnette, Cordelia "Shorty" Ellis, Louise ? (Catherine's college friend), and Barbara Hollberg. (Courtesy of Catherine and James Barnette.)

Friends did a number on the drive away car for newlyweds James and Catherine Barnette on their wedding day, Wednesday, August 10, 1955. Catherine's father, J.P. Brown, gave her the 1948 Plymouth when she was a sophomore at Bessie Tift College in Forsyth. Behind the couple is a 1940s Chevrolet and a 1950s Pontiac. (Courtesy of Catherine and James Barnette.)

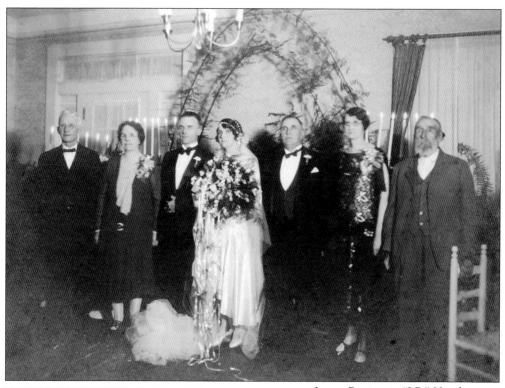

James Benjamin "J.B." Hutchinson stands in the center with his new bride, Kathleen Estes. The newlyweds are pictured on their wedding day with their families. Standing from left to right are Lee and Lizzie Hutchinson, J.B. and Kathleen (Estes) Hutchinson, Nathaniel and Blanche Estes, and Uncle Jim Estes. (Courtesy of Jane (Hutchinson) Arnold.)

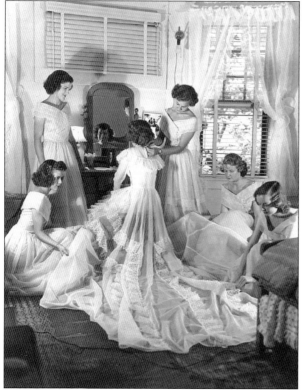

Bridal attendants help Joyce Cleveland prepare for her wedding to William "Bill" Smith at Senoia Baptist Church. Cleveland attended both Auburn University and Draughn's Business School and later became a stay-at-home mother for Skipper, Dodie, Debbie, and Nerine. She returned to work at the age of 40 and began her 30-year career with Southern Mills, retiring as the corporate purchasing manager. (Courtesy of Joyce (Cleveland) Smith.)

Charlie Homer Travis tips his World War I military hat as he is photographed with a well-dressed unidentified friend. This photograph was taken shortly before Travis went off to war. (Courtesy of Barbara (McDaniel) Ray.)

Brothers Ken (left) and Greg (right) Crook sing Christmas carols as their sister Cheryl accompanies them on the piano in this 1960s photograph. (Courtesy of Patricia (Yarbrough) Crook.)

Bill and Randy Todd enjoy time at the Senoia pool in the Senoia Area State Park, built in 1958. Their baby brother Brantly (held by Randy) was not so happy in the moment this photograph was taken. (Courtesy of Randy Todd.)

Newlyweds James and Lucy Welden enjoy picnicking at a family reunion at Tinsley Mill in Peachtree City. The mill was located on the site of Flat Creek Country Club and was owned by Papa Girard "Gerd" Tinsley, who was Lucy's grandfather. The children in this 1946 photograph are, from left to right, Patsy (Simmons) Tinsley, Anne (Worrell) Awtry, and Jerry Tinsley. (Courtesy of Gary Welden.)

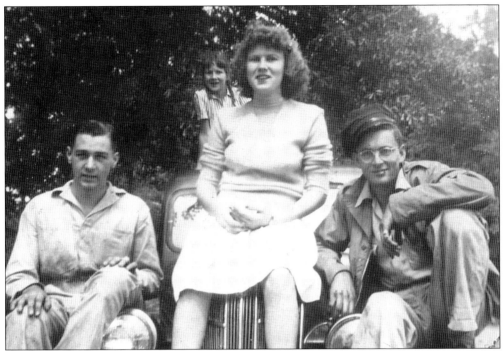

Billy Shell (left) poses for a picture with Sue Welden and Reuben Williams in the mid-1940s. Sue's younger sister, Katherine "Callie" Welden is seen behind Sue. (Courtesy of Cynthia (Welden) Williams.)

Jimmy Hutchinson attended the University of Georgia and was a huge Bulldogs fan. He is pictured here with his sister Eleanor (Hutchinson) Smith's children. From left to right are young Dr. Andy, Dr. David, and Benjamin. Hutchinson adored his three nephews, as did his wife, Jane. (Courtesy of Jane (Hutchinson) Arnold.)

Bicycles were "one size fits all" when Eleanor Cooper and Reuben Williams were children. Williams remembers spending more time fixing flats than riding his bike. Cooper recalls receiving her bicycle for Christmas and barely being able to climb on it. The photograph of Cooper below was taken on the lawn of the Frank Daniel house, where Dr. and Mrs. Bill Greening live today. (Left, courtesy of Reuben Williams; below, courtesy of Eleanor Cooper.)

Eight
NOTABLE LANDMARKS

Mayor Lester Mann shakes hands with Senoia city clerk Betty Cookman in front of his residence, also known as the Linch/McKnight/Mann/Yarbrough/Kolbenschlag house. The woman on the left is unidentified. Confederate captain William David Linch built Senoia's grandest home for his daughter Mary on the occasion of her marriage to Carl McKnight. (Courtesy of Betty (Cookman) Armstrong.)

A talented artist, Mary (Linch) McKnight painted this 10-by-20-foot mural on the wall of her home, which has been preserved. In addition to painting, McKnight was an accomplished pianist and asked that the front door of her home be built off-center to accommodate her grand piano. Award-winning photographer Lori Kolbenschlag's Legacy Portrait Studio is housed on the premises today. (Courtesy of the Kolbenschlag family.)

An unidentified couple sits on the rock wall in front of the McKnight/Mann/Yarbrough/Kolbenschlag house. Several have thought it might be original owners Carl and Mary McKnight, but some disagree. Others speculated that the gentleman might be Ralph McKnight, son of J.A. and brother to Carl and Paul Sr. Sadly, those who would have been able to identify them with certainty have passed on. The house behind the couple on the left was once the home of Senoia's first police chief, George Lee Welden, and his family. Later, it was home to Pete and Libby Bedenbaugh before they moved farther down Pylant Street near Rose Cottage. Residents who lived at different times in the house to the right of the couple were Oscar Mann, the Wilson Whatley family, and later Founders' restaurateurs Todd and Elizabeth Baggarly, who owned the upscale family restaurant on Main Street with Glenda and Tray Baggarly. (Courtesy of the Senoia Buggy Shop Museum.)

This is the home of James Harrison "Tray" Baggarly III. Six generations of Baggarlys have lived in the house, including Walter Branham and May (Harrison) Baggarly; James Harrison Sr. and Rubye (Rives) Baggarly; James Harrison Jr., Walter, and Warren Baggarly; Tray Harrison and Kristen Baggarly; and Hayden, James Harrison IV, Rhys, and Sophie Baggarly. This is the oldest existing photograph of the home and was provided by Fayette County historian John Lynch, who is related to the Baggarly family. (Courtesy of John Lynch.)

May (Harrison) Baggarly poses for a portrait in 1900. She was married to Walter Branham Baggarly and lived in the Baggarly family homeplace on Baggarly Way. Guests considered themselves privileged to receive a handwritten invitation to afternoon teas that May routinely held at her home. May and Walter were the parents of James Harrison "Jim" Baggarly Sr. (Courtesy of Janet Baggarly.)

In the 1920s, George Parks Rives (1878–1951) sits with his daughter Rubye beside him and his wife, Pansy Lee (Ayers) Rives (1887–1955), standing behind them. Rubye (Rives) Baggarly was the wife of Jim Baggarly Sr. and the mother of Jim Jr. and the infamous Baggarly twins Walter and Warren. (Courtesy of the Senoia Buggy Museum.)

Dot is one of many dogs that found a happy home with the Baggarlys and is depicted in front of the family homeplace on Baggarly Way. James Barnette Sr. went bird hunting with Jim Baggarly Sr. and remembers how fun it was to watch him work his bird dogs. Current resident Tray Baggarly notes, "There are two dog cemeteries that mark the sites of many well-loved dogs at the back of the house." (Courtesy of the Senoia Buggy Shop Museum.)

Catherine and Hiram Todd stand on the front porch steps at 6 Couch Street where they lived with their parents before moving to Rosewood Cottage on Pylant Street. Claudia and Bill Wood, who are the proprietors of Katie Lou's BBQ and the parents of Jennifer Wood-Malone and Rutledge Wood (host of *Top Gear*, *NASCAR Trackside*, and *Speed Road Tour Challenge*) presently reside at Rosewood Cottage. (Courtesy of Randy Todd.)

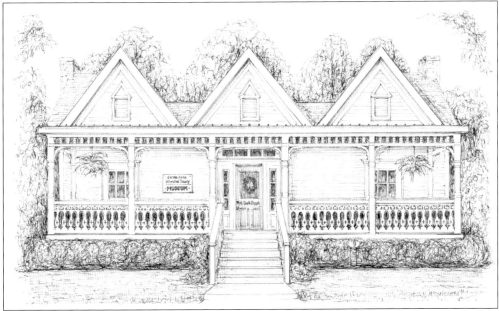

Established in 1978, the Senoia Area Historical Society (SAHS) purchased 6 Couch Street via money raised from local fundraisers. Jack Thompson encouraged the 1991 purchase of the property for a museum. According to charter member Nancy Roy, SAHS partnered with Senoia Masonic Lodge and the Lions Club to establish the McIntosh Arts and Crafts Country Fair. JoAnne Utt and Mary Brown spearheaded the successful effort for Senoia's National Register of Historic Places designation. (Artwork by Nancy McConeghy.)

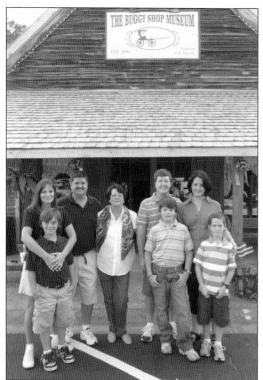

Janet Baggarly and family stand before the Senoia Buggy Shop Museum (housed in the 1890 Baggarly Bros. Buggy Shop building) that her husband, Walter, opened in 1994. From left to right are Sher, Scott, and Logan Baggarly; Janet Baggarly; and Michael, Terri, and their sons Sam and Will Baggarly. The museum is open during Memorial Day festivities for the September car show and the first Saturday in December before the Christmas parade. (Photograph by Carla (Cook) Smith.)

Pictured here in 1918 at the corner of Travis and Bridge Streets, the Vining/Travis/McDaniel home (also known as *the Fried Green Tomatoes* house) is one of Senoia's most popular landmarks. Sue and Olin McDaniel settled in the ancestral home where Olin was born when he retired from the military in 1957. Olin's Vining and Travis ancestors came with the building of the railroad and were Central of Georgia depot agents for three generations. (Courtesy of Barbara (McDaniel) Ray.)

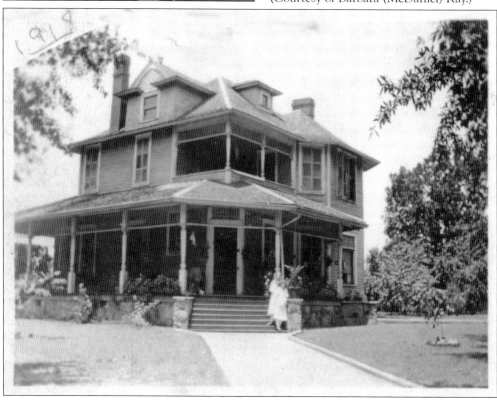

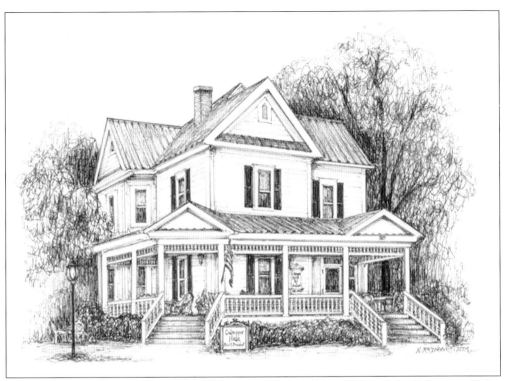

Senoia's first doctor, John Addy, built this house around 1865. Dr. Wilbur Fiske Culpepper (1857–1937) purchased it in 1902, making the great parlor his office. He was a Senoia physician for over five decades. He also once co-owned a drugstore with Charles Emory Culpepper, who left Senoia (multimillionaire via Coca-Cola). The drugstore was later destroyed by fire. A bed and breakfast from the 1980s to 2018, the home is currently a private residence. (Artwork by Nancy McConeghy.)

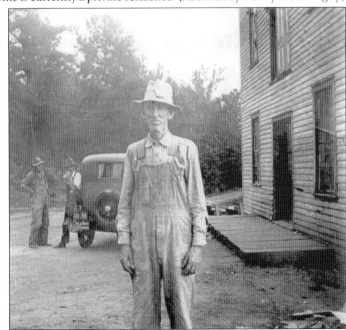

Ed Hardin, Annie Bailey's husband, stands at the Elder's Mill entrance in the 1940s. Miller James Thomas "J.T." Barnette earned $15 a month to grind corn and wheat at the mill. Barnette's son James was born on the property on September 20, 1933, and spent his youth playing in the stream and finding crawdads under rocks at the dam. Fishing worms were plentiful where the corn cobs piled up under the mill, and many enjoyed fishing there. (Courtesy of John Tidwell.)

George Couch resided on a 100-acre farm at Elder's Mill and Sunnyside Roads and ran the syrup mill just down from Elder's Mill. In the fall, Couch cooked the syrup, which flowed through 8–10 troughs. Cane juice went into the first trough. As juice flowed from one trough to another, the top was skimmed, and by the time it reached the last trough, the syrup was done and put up in gallon tins. "The spring across the road from our house was our water source, and we hauled water from there. It was fun to piddle in the stream," James Barnette recalls. "There was a big snow in 1939, and Daddy rolled a big pile of snow down toward the spring where the syrup mill had been. He built a big snowman that lasted until spring. It was fun to come home from school and see my snowman every day." Sterling Elder owned the mill, and his grandson M.H. was just a few years older than James. The boys sometimes rode horses together. This photograph was taken after a storm knocked trees onto the mill, damaging the roof before it caved in. (Courtesy of David and Suzanne Pengelly.)

There was no insulation for the house James Barnette (pictured) grew up in at Elder's Mill. The house was raised several feet above ground, and he could walk under it as a boy to play. At that time, the road from Senoia came to Elder's Mill Road right in front of the house, not around the creek toward Gordon Road like it does today. The road was cut after the Barnette family moved from Elder's Mill. There were horses and mules at the "big house," the Elder residence. The barn had a run-through from the pasture into the lot with stalls on either side. Barnette routinely climbed the ladder into the loft to watch the horses run under his feet. John Elder was the caretaker of the property and became a good friend to Barnette. Elder helped Doris Pepper Barnette (James's mother) tend to Sharon when she was a baby, and he sometimes babysat. Barnette fondly remembers Elder being like part of the family, sitting at the table and eating super with the family in the evenings. (Courtesy of James Barnette.)

J.T. Barnette chases after his young son James on the Elder's Mill property around 1935. James has wonderful memories of living near the mill when his father was a miller and recalled that the dam was a favorite fishing spot for many. Suzanne Pengelly reports that M.H. Elder's wife, Jo, was the last Elder family member to live at the homeplace on the Elder's Mill property. (Courtesy of James Barnette.)

Lucy and Kathryn Tinsley enjoy the Elder's Mill waterfall in the early 1940s. Senoia families took corn and wheat from their farms to the mill to have it ground into meal and flour. Martha Gill recalls going with her father, Wreathy Williams, with wheat from their farm. She relates, "When Daddy got home with the flour, Mother got to work making bread, which she had on the table in time for supper." (Courtesy of Gary Welden.)

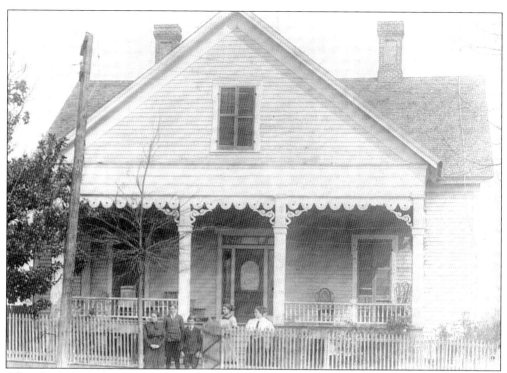

Allen H. Jones, who formed the Jones Electric Light and Power Company in 1910, lived in this house on Johnson Street, shown here in 1904. A Senoia Baptist deacon for 46 years, he is remembered for his generosity and dedication to the church. He walked daily to Starr's Mill in Fayette County to "light up Senoia," and at the end of the day, he returned to the mill, turning off the electricity at precisely 9:30 p.m. Electricity sometimes went out when eels got caught in the dam's wheel or torrential rains flooded the dam. (Courtesy of Cindy Divido.)

Starr's Mill (shown here in 1902) is a popular landmark. Hananiah Gilcoat built the first mill in the 1820s. The second mill burned in the 1890s. W.T. Glower built the current mill and concrete dam in 1901. A cotton gin operated there until the late 1940s. The dam was a popular spot for baptisms. When Frank Harris was baptized, he heard someone say, "I saw the Lord," and he replied, "I saw a little brim." (Courtesy of the Fayette County Historical Society.)

Starr's Mill owners included the English, Parker, Starr, and Jones families. The Starr name stuck for the mill and the surrounding community. W.K. Massengale was the miller for the Jones family, who ran the mill until it closed in 1959. In this 1940s photograph, Edna Bailey Kerlin (the mother of Fayette County Historical Society's first president, Bobby Kerlin) stands on the dam at Starr's Mill. James Bailey and Joan (Kerlin) Pollard are seated. For decades, Bobby Kerlin gave lectures on-site about the history of Starr's Mill on Labor Day weekend. (Courtesy of the Fayette County Historical Society.)

One of Senoia's oldest homes, the Forbus/Williamson/Downs house, originally built in the Federal style in 1834, was remodeled as a Victorian with a wraparound porch in 1890. In 1995, Carter Williamson remodeled the house where Moses Shields once lived. Gail's Antiques owner Gail Downs (Senoia Downtown Development Authority Promotions Committee chairwoman) has lived in the house with her family for over 20 years. (Artwork by Nancy McConeghy.)

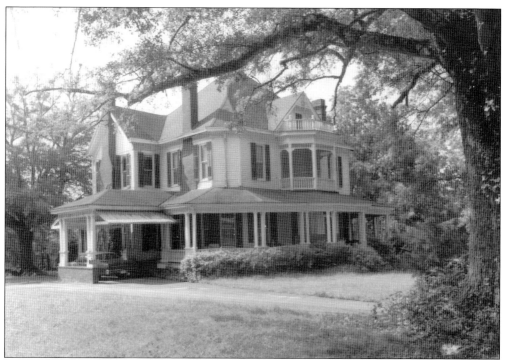

Berry Whatley purchased Rufus L. Hardy's 1884 home in 1950 when he and his wife, Percy, obtained the property for $25,000. Hardy was president of Farmers and Merchants Bank from 1915 to 1946. A sawmill owner, Whatley harvested enough timber from the property to pay for it. Arrowheads discovered on-site reflect where Lower Creek Indians once lived near the creek. The house originally sat close to the highway, but it was moved back a mile several years ago, spurring wild rumors of "the house that disappeared." (Courtesy of Susan (Robinson) Whatley.)

Berry and Percy Whatley were the first of five generations of Whatleys who lived on the 493-acre family farm in Senoia. Berry sang sacred harp music and had a shaped note hymnal provided to him when he attended Senoia Baptist Church, according to James Barnette. Percy was an accomplished pianist, playing for Glen Grove Baptist Church where Berry was the music director from the 1920s to 1972. Ronnie Whatley led music there from 1976 to 1985 and remembers singing with family (including duets with his wife, Susan) and friends every Thursday night at his sister Saundra Grace's house. (Courtesy of Ronnie and Susan Whatley.)

Lee and Lizzie Hutchinson ordered their house from Sears. Materials were delivered via train at a cost of $10,000 for their Seavy Street property across from the AB&A depot. According to Martha Gill, "The large front porch was a place friends frequently visited. Sometimes, people would meet the train on Sunday afternoon to greet passengers from Atlanta." The house is pictured here in 1949. (Photograph by Jim Baggarly; courtesy of Tray Baggarly.)

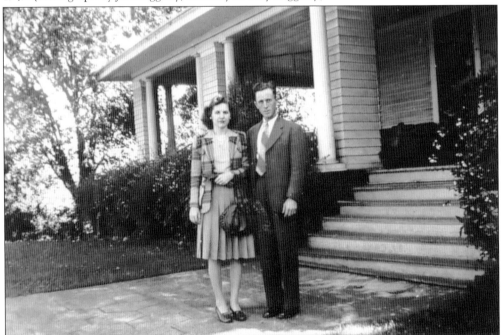

Martha and Benton Gill stand before the Lee Hutchinson house, where they rented an apartment as newlyweds. Martha recalls coming home from her job as a bookkeeper at Southern Mills and visiting with Lizzie Hutchinson on the veranda. The Gills' first home consisted of one and a half rooms and a bath. The couple lived there until 1949, when their home on Pylant Street was completed. (Courtesy of Martha Gill and Marla (Gill) Dugan.)

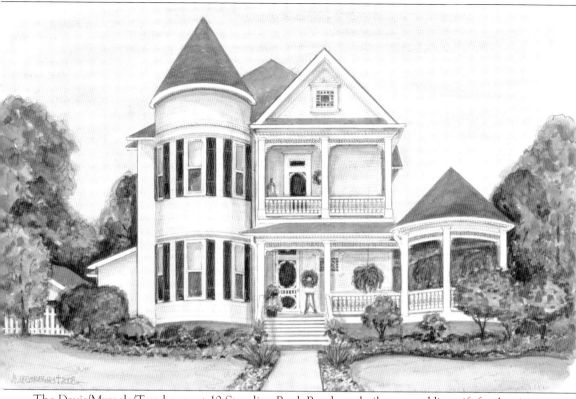

The Davis/Myracle/Tyre house at 10 Standing Rock Road was built as a wedding gift for Annie (McLane) Davis, who lived there from the time of her marriage until her death in 1971. The matriarch of Senoia Baptist Church for many years, Davis taught Sunday school classes for the older ladies of the church, which included Doris (Pepper) Barnette. When her health declined, Estelle Travis's daughter Frances cared for Davis at her home, which spared her from living in a nursing home. Later occupied by the Myracle and Tyre families, both gracious hosts, the home has served as a delightful venue for garden parties and fundraisers for Senoia Area Historical Society. (Artwork by Nancy McConeghy.)

𝕾𝖊𝖓𝖔𝖎𝖆 𝕭𝖆𝖕𝖙𝖎𝖘𝖙 𝕮𝖍𝖚𝖗𝖈𝖍

SENOIA, GEORGIA

July 2, 1967 Walter C. Rosier, Jr., Pastor

Mrs. Annie McLane Davis

𝕮𝖊𝖓𝖙𝖊𝖓𝖓𝖎𝖆𝖑 1867-1967

Devoted to Senoia Baptist Church, Annie (McLane) Davis and her friend Estelle (Vining) Travis made and sold handwork, conducted bazaars, and held suppers as fundraisers for church improvements. Davis (pictured) was honored by the church in July 1967, shortly before her 91st birthday. Brantly Institute's beloved teacher, Coral Moses Hand, taught Sunday school classes for the younger women in the church. (Courtesy of Martha Gill.)

Nine

COMMUNITY, SCHOOL, AND FAMILY LIFE

The Senoia Area Historical Society partnered with the Lions Club and Masonic Lodge to establish the McIntosh Arts and Crafts Country Fair. The annual event took place in the summer at Seavy Street Park and included 100 exhibits. Jim Baggarly Sr. had a history booth near antique dealers inside the Freeman Sasser building. The Lions Club participated with a concession stand. Margaret Lunsford (right) participated as an antique dealer and is pictured here with some of the antiques and collectibles she exhibited. The lady at left is unidentified. (Courtesy of Janet Baggarly.)

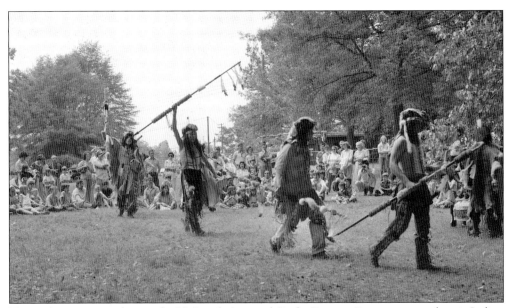

Native Americans perform at the McIntosh Arts and Crafts Country Fair wearing authentic Indian dress. Geoff Tinsley recalls that they chanted while they danced: "The Indians pretended like they were hunting and came back from the hunt eating raw meat. As a seven-year-old boy, the Indians were the highlight of the festival for me." (Photograph by Melvin Cheek; courtesy of Geoff Tinsley.)

Joe "Hoss" Garrard (left) sits next to Frank Harris (right) at the McIntosh Arts and Crafts Country Fair. Both Garrard and Harris are known for telling funny stories and likely laughed a lot together that day. A native of Washington, Georgia, Garrard received his forestry degree from the University of Georgia and was well known in the area as a forester. He married Shirley (Tate) Garrard in 1958, and they raised their family in Brooks. Harris received a Bronze Star for serving in six major World War II battles and was a mechanic for Hutchinson's Ford and a farmer before starting his pulpwood business, which ran for 53 years. Harris married 1949's most popular girl, Georgene Currie, and together, they adopted their son Bill. (Photograph by Melvin Cheek; courtesy of Geoff Tinsley.)

Beauty queen Dianne Pollard was crowned the first Miss Senoia Area Park in 1958 and later as Miss Coweta County Livestock, pictured here. The beautiful girl married Billy Adcock, whom she met at the Gulf station her father, J.T. Pollard, owned on Highway 16. Together, they had one daughter, Kim, who married race car driver Clint Smith. (Courtesy of Dianne (Pollard) Adcock.)

Senoia men gathered above R.S. Sewell's Mercantile (where the Masonic Lodge held meetings before their building was completed) purportedly to discuss establishing the Senoia Housing Authority. From left to right are Doug Wilson, three unidentified men, Jim Baggarly Sr., Bruce Fry, P.R. McKnight Sr., Ray Sewell, Judge Byron Matthews, Harold Awtry, and Bob Walt Freeman. (Photograph by Melvin Cheek; courtesy of Geoff Tinsley.)

This brick building on Clark Street replaced the Brantly Institute's original wooden structure, which was destroyed by fire. Callie Welden recalls that the school had a wonderful library that stayed open after school closed and offered summer reading programs, which she greatly enjoyed. In later years, the Senoia Downtown Development Authority purchased the school property, divided it into lots, and sold them as residential property. (Courtesy of Janet Baggarly.)

Dr. Franklin Marion and Margaret Ezzard (Collier) Brantly are seen here around 1905. Dr. Brantly (1818–1912) was a beloved Senoia physician for many years, and it was in his honor that the high school building was named the Brantly Institute. He moved to Senoia around 1865 and practiced medicine until he was too feeble to continue. Dr. Brantly was the oldest member of the Georgia Medical Association and a prominent Mason when he died at the age of 94. (Courtesy of Brantly Todd.)

The 1944 graduation class of Senoia High School at the Brantly Institute is depicted in this photograph. Included in this image are Mary Brantly (first row, second from left), Roy Tinsley (second row, far left), and beloved school teacher Coral Moses Hand (second row, center). (Courtesy of Bill Todd.)

Frances Travis wore the customary white dress for her Senoia High School graduation in 1922. The daughter of Estelle and Willis Sidney Travis, she was a member of Senoia Baptist Church and known for her kindness. She was a companion to Annie (McLane) Davis during her last days, so that Davis would not have to move to a nursing home. Her hobby as a shutterbug preserved some unique history. (Courtesy of Barbara (McDaniel) Ray.)

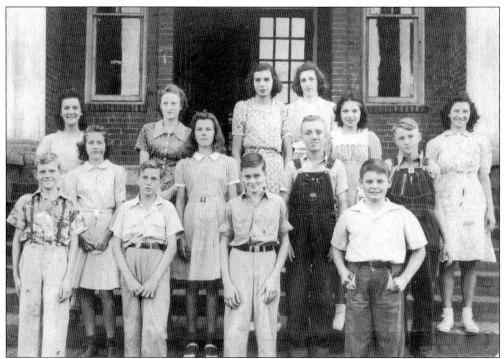

Brantly Institute Junior High students include Reuben Williams (first row, third from left), Roy Tinsley (first row, far right), and Mary Brantly (second row, second from left); all the others unidentified. (Courtesy of Randy Todd.)

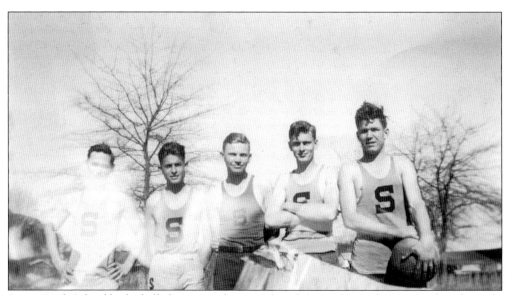

Senoia High School basketball players seen here are, from left to right, Paul Counts, Edward Couch, Eugene Pollard, Reuben Williams, and Bobby Adcock. (Courtesy of Cynthia (Williams) Christopher.)

The 1963 sophomore superlatives Bill Tinsley and Beverly (Williams) Waters were popular at East Coweta High School. Men still whisper Beverly's name with reverence and a catch in their throat. "She was the sweetest woman who ever walked the earth," both Bill Tinsley and Ellis Crook have said on more than one occasion. (Courtesy of Bill Tinsley and Peggy (Tinsley) Hall.)

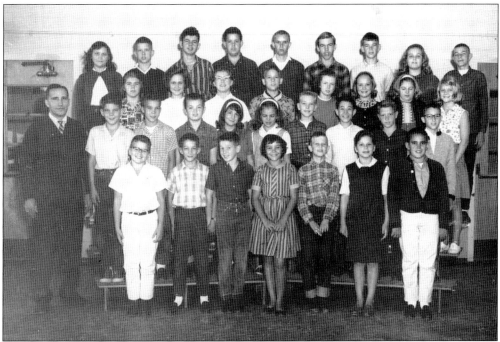

Wade Hancock's seventh-grade class is pictured here. From left to right are (first row) Lee Waters, Richard Glazier, Carl McKnight, Linda Bishop. Ray Stevenson, Delores Spencer, and Jerry Sherman; (second row) Randy Todd, Ricky Spratlin, Glinton Brown, Martha Ann Schuler, Ann Hubbard, Ronnie Hannah, Billy Pate, Wesley ?, and unidentified; (third row) Elaine Hunnicut, Peggy Wood, Debbie Smith, Tommy Johnson, Patricia Pope, Sue Chambless, Reba Whitlock, and Glinis Led; (fourth row) Patsy Williams, Russell Byrom, William Neill, Tom ?, unidentified, Gilbert Thomas, Richard Bedenbaugh, Angela Tinsley, and Paul Debry. (Courtesy of Randy Todd.)

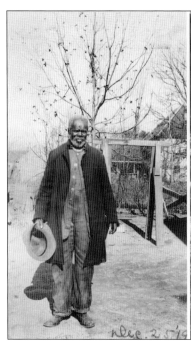
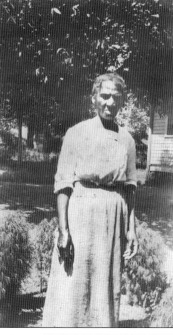

Husband and wife Al and Annie Thurmond are pictured in Senoia on Christmas Day in 1925. (Courtesy of Barbara (McDaniel) Ray.)

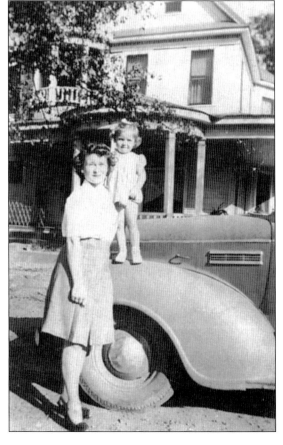

Audrey Hicks and her daughter Beverly stand in front of the home of Elmos "El" and Maybell (Whatley) Morgan on Main Street in Senoia. Beverly and her mother lived with her Morgan grandparents during World War II while her father, Raymond Edward Hicks, was serving the war effort in Europe. Beverly remembers fishing at Line Creek with her grandfather and Grandmother Morgan's reminder that "a true Southern lady has an iron fist in her delicate, lacy glove." (Courtesy of Beverly (Hicks) Walker.)

Edna and Edwin Cheek are pictured in Senoia around 1945. Geoff Tinsley thought his great-grandfather Edwin was a rock star. He relates, "People from Rockdale, Fulton, and Chatham Counties came to Senoia and brought chairs for him to cane." He stored cane spools in the shed, which he soaked in five-pound buckets of water to make the cane more malleable, creating intricate bottoms (not just lap weaving). (Courtesy of Geoff Tinsley.)

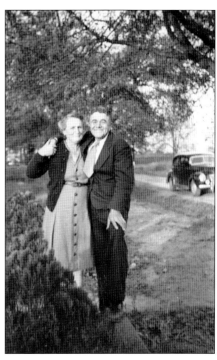

Taken at the Senoia home of Dr. Franklin Marion and Margaret Ezzard (Collier) Brantly (not pictured) around 1905, this photograph shows Belle (Brantly) Jones (wife of J.H. Jones), standing at center, and her daughter Grace Elizabeth Jones (age 12) standing to the right. Grace married Dr. James Mercer Tribble, a beloved Senoia physician like her grandfather. The other Brantly relatives are unidentified. (Courtesy of Randy Todd.)

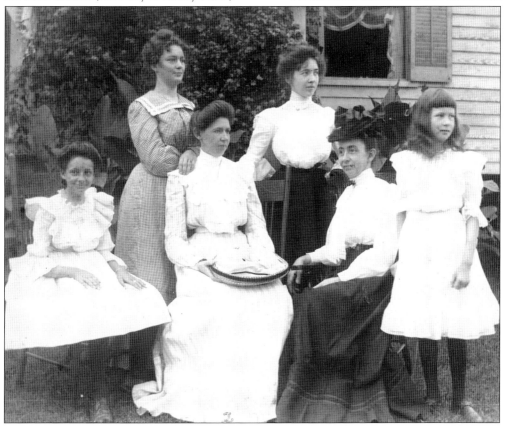

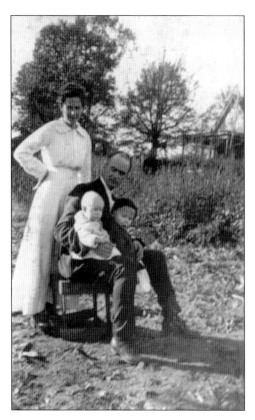

Ben A. Nolan is pictured with his first wife, Emmie, and their children. The photograph was made by Frances Travis, who lived across Bridge Street from the Nolans. Following Emmie's death, Ben married Alma Kate Couch. Alma Kate played the piano in the back of a mule-drawn wagon when the family moved from their farm on Elder's Mill Road to live in the house her father built in 1915 at Couch's Hill on Highway 16. (Courtesy of Sue (Adams) McDaniel.)

Ten-year-old Lucy Tinsley stands next to her grandmother, Judith Margaret White (seated), in front of the Tinsley family homeplace in Spring 1935. Lucy's mother, Margaret White Tinsley, is depicted at right. (Courtesy of Brenda and Gary Welden.)

Libby Bedenbaugh was an excellent seamstress, sewing clothes (sometimes without a pattern) for her children (Melanie, Bonnie, and Richard, pictured respectively). Senoia was a small, country town where everyone knew their neighbors, and no one locked their doors when she married Pete in 1940. The family attended Senoia Baptist Church, where Libby was a member for 50-plus years, teaching Sunday school and singing in the choir. Her husband, Pete, was a Georgia state revenue agent and helped solve the infamous 1948 murder in Coweta County. Both Libby and Pete were cast as extras in the movie about the murder. (Courtesy of Libby Bedenbaugh.)

David and Lucille (Wilson) Parks purchased their house on Morgan Street for $1,400 when their daughter Mary Ann was four years old. The house built by Otie Sasser was purportedly constructed between 1880 and 1890. The workman who did the wiring for Senoia electricity stayed at the Parks home until wiring for the town was completed. David, who was Senoia's barber and beekeeper, enjoyed the perk of having his house wired first. (Courtesy of Mary Ann (Parks) Reese.)

Ruth (McLain) Gardner, wife of Senoia dentist James Cleophas Gardner, holds her infant daughter Ruth as Frances Travis takes their photograph. Mary Ann (Parks) Reese remembered going on picnics with the families of Dr. Gardner and Dr. Tribble when she was a child. Ruth was a good cook and always made the picnic. Reese reported that "Dr. Gardner had an old drill that made all kinds of racket when he worked on your teeth." (Courtesy of Barbara (McDaniel) Ray.)

The daughter of James Cleophas Gardner, Senoia's only dentist, Ruth Gardner is pictured with her baby doll around 1919. She died the following year at the age of four, perhaps from the Spanish influenza. (Photograph by Frances Travis; courtesy of Barbara (McDaniel) Ray.)

The Cook family, who owned Cook's Grocery Store on Main Street in Senoia, pose for a family portrait. Pictured are, from left to right, (first row) Sally Thompson, Laura Thompson Cook, and Tom Cook; (second row) Laura and Tom's children Robert, David, Howell, and Wilbur Cook. Howell Cook opened the second Cook family store in Senoia. (Courtesy of Frances Pollard.)

Relatives visit Carl Williams's farm in the 1940s. From left to right are (first row) Robbie Williams, Jeannie Marie Evans, and Herbie Williams (Herbie and Carl are brothers and their father is Carl Carter Jr.); (second row) Bobby and Jack Evans, Jeanette Williams (Reuben's sister), and Carl Carter Williams III. The Evans children are the grandchildren of Hazel Williams's sister Mabel (Jones) Culpepper, all from Griffin. Robbie Williams was Reuben's brother Will's son. (Courtesy of Cynthia (Williams) Christopher.)

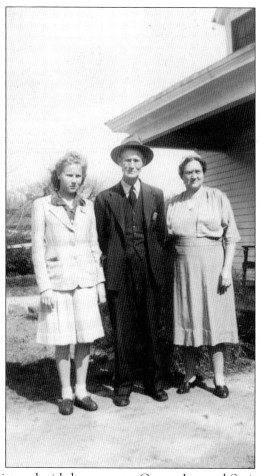

Sue Welden (left) is pictured with her parents, George Lee and Susie (Thompson) Welden, around 1943 when the family lived on Pylant Street. At this particular time, all Senoia residents received their mail via a post office box (No. 153 for the Weldens). George and Susie moved to Senoia in the mid-1930s from the Bethel community, where they had farmed with their eight children (listed in birth order): James Lee Welden, George Welden Jr., Charles Francis Welden (named after C.F. Hollberg Sr.), Annie Eliza "Ann" (Welden) Stegall, Lewis Glen Welden, Susie Ella "Sue" (Welden) Williams, Mary Evelyn (Welden) Brown, and Kathryn Faye "Callie" Welden. The Senoia United Methodist Church pastor, Rev. Noel Powell, asked Mayor C.F. Hollberg Sr. if he had a job George Sr. could do so the Welden family could move to Senoia to be a part of his congregation. George served as Senoia's first police chief for 25 years, until his death in 1959. Susie is remembered for helping people whenever she could. She was active in the women's society at Senoia United Methodist Church and a Girl Scout leader. She saved the life of Van Gross when he was a breach baby by turning him before the doctor could get there. All of the Welden children married and had children of their own except for Callie, who remains an "unclaimed blessing." Susie Welden repeatedly told her youngest daughter, "Never marry anyone you could live without." Callie relates, "I never met anyone I couldn't live without. I got a good job working in Atlanta at Sears Roebuck and never worked anywhere else, retiring after 37 years." Callie traveled the world extensively (Asia, Europe, United Kingdom, Turkey, Hong Kong, Singapore, China, Africa, Ireland, the Holy Land, Amsterdam, the Bahamas, Japan, and Alaska and continues to travel to Honduras on annual mission trips). She notes, "I have plenty of nieces and nephews to love and never felt the need to have children. (Courtesy of Cynthia (Williams) Christopher.)

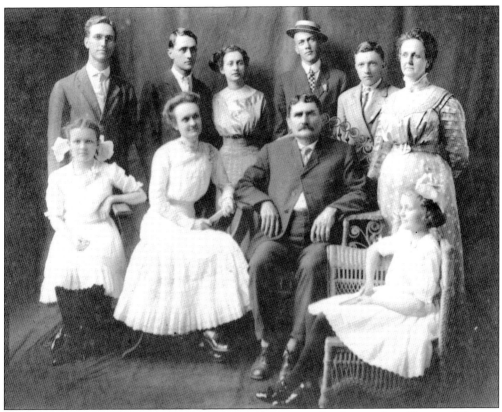

The Carmichael family lived at 6 Couch Street (the present-day Senoia Area Historical Society Museum) from 1900 to 1905. Pictured in 1911 are, from left to right, (seated) Ina Mae, Bessie Alma, Abram Pendleton (father), and Grace Elizabeth; (standing) Walter Pendleton, Patrick Gay, Pauline, Roy Calhoun, Herman Eakes, and Beulah Elizabeth Gay (mother). The Senoia Area Historical Society Museum is open Fridays and Saturdays from 1:00 p.m. to 4:00 p.m. (Courtesy of JoAnne Utt.)

Pierce S., a friend or relative of the Baggarly family, stands in front of the Baggarly homeplace for a patriotic portrait. The Morgan/Wendt house stands directly behind Pierce. This photograph was taken around 1919. (Courtesy of the Senoia Buggy Shop Museum.)

Dock and Margaret Tinsley are seated at center in this family portrait. Pictured with them are, from left to right, (first row) Patsy and Jerry; (second row) Kathryn, William, Lucy, and Roy. (Courtesy of Peggy (Tinsley) Hall.)

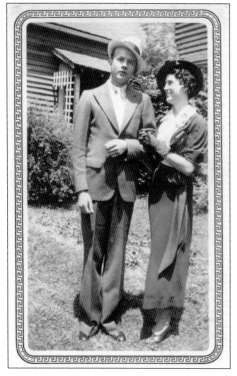

Quickly smitten upon meeting Sue Adams in 1935, Olin McDaniel told her he could not return to Georgia without her. Olin and Sue, seen here in their 1936 wedding photograph, were married for 70 years. Sue had fun working as an extra for *Fried Green Tomatoes* when the wedding reception and funeral were filmed in her yard. Fannie Flagg was delighted with the McDaniel home, which was what she imagined when she wrote the book. The 100-year-old oak tree that stood guard over the McDaniel home held Idgie's tree house. Sue lived to be 102 (about the same age as the old oak tree, which died a week before she did). A rendering of the tree adorns her marker in the Senoia cemetery. (Courtesy of Barbara (McDaniel) Ray.)

Pictured on her wedding day to James Barnette Sr., Catherine (Brown) Barnette, stands with her father, J.P. Brown. Downtown stores were closed on Wednesdays, and since Brown was the manager of Hollberg's store, Wednesday was the best day for him to give his daughter away and for the townspeople of Senoia to attend the wedding. James Barnette recalls, "The Baptist Church was overflowing with people on our wedding day." In addition to work at Hollberg's, Brown sold cars from the side lot of his home on Seavy Street (next to the Lee Hand house). (Courtesy of Catherine and James Barnette.)

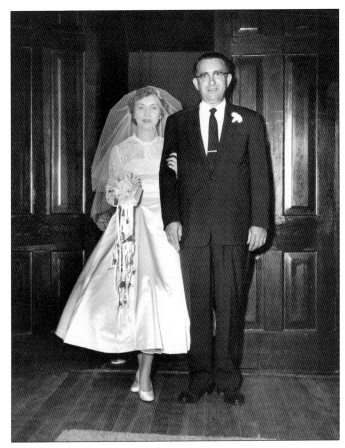

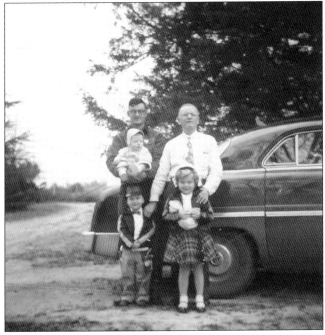

Berry Whatley (the elderly gentleman) stands with his son Wilson and Wilson's children Saundra, Jerry, and baby Ronnie on the Whatley family farm in the winter of 1954. (Courtesy of Susan (Robinson) Whatley.)

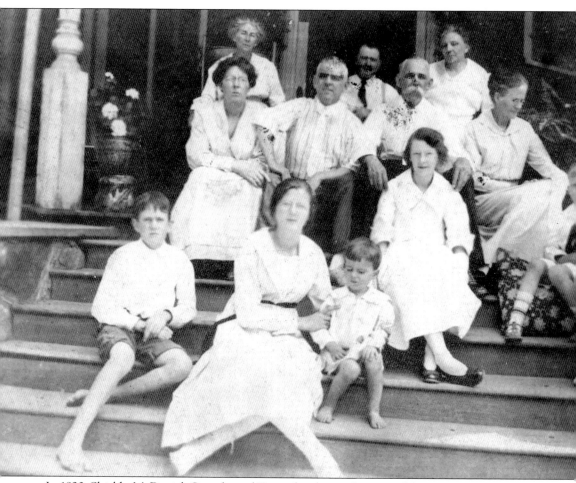

In 1920, Shields, McDaniel, Crouch, and Travis family members posed for a portrait on the steps of the Vining/Travis/McDaniel house. From left to right are (first row) W. Olin McDaniel, Frances Travis (she later gave the home to Olin), and Robert Shields Jr.; (second row) Margaret Crouch and Olin's brother George McDaniel; (third row) Irene (Smith) Shields, Robert Shields, Willis Sidney Travis, and Estelle (Vining) Travis; (fourth row) Aunt Mary Shields, unidentified, and Hattie (Shields) Crouch. (Courtesy of Barbara (McDaniel) Ray.)

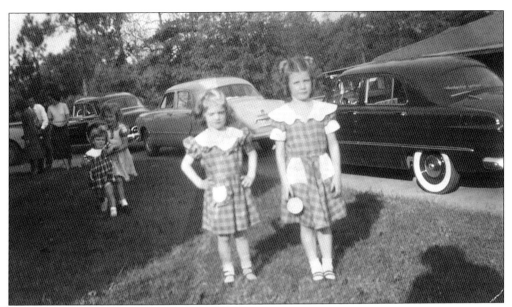

Judy (left) and Eleanor (right) Cooper stand in the foreground of this vintage photograph. People in the background are unidentified. The girls lived with their family and Molly Sibley at Sibley's boardinghouse on Bridge Street. An "unclaimed blessing," Molly was the sister of Lillian Hollberg, who was married to C.F. Hollberg Sr. The girls' father, Johnny Cooper, owned an Amoco gas station on Highway 16. Eleanor was crowned Miss Senoia as a young woman. (Courtesy of Eleanor Cooper.)

Marvin Duke (left) stands with his brothers (unidentified) in the 1930s. Duke left Senoia to play professional baseball for the New York Yankees. He returned home and lived out his days in Senoia with his wife, Bennis, who taught school in Senoia. Marvin and Bennis had one child, Sonny Duke. Marvin helped with Little League, and the family was active in Senoia United Methodist Church. (Courtesy of Aimee Duke.)

From left to right, Olin, Sue, and Barbara McDaniel pose for a family portrait on Barbara's fourth birthday in February 1941. (Courtesy of Barbara (McDaniel) Ray.)

Over 300 people turned out to celebrate the 50th anniversary of Dr. James Mercer Tribble's medical practice in Senoia. Dr. Tribble, the man with white hair in the foreground of the photograph, is looking down with a napkin in his hand. The beloved physician delivered over 1,000 babies. Rev. James Lee Welden, who was the first Caucasian baby delivered by Dr. Tribble, was named after the good doctor. (Courtesy of Frances Pollard.)

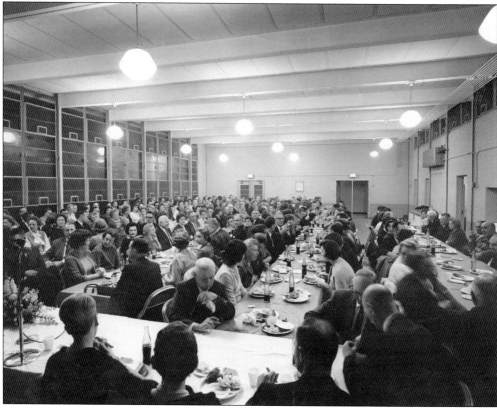

Ten

LIGHTS, CAMERAS, ACTION!

Frank Harris met Georgene Currie at the picture show in Senoia, where she worked. He watched a lot of westerns at Senoia Theatre and remembered seeing *Gone with the Wind* there. When Andy Nations owned the theater, he showed *The Alamo* a lot. Billy Adcock ran the projector at one time. Alice (McKnight) Ramsey recalls seeing *Song of the South* there as a child. (Artwork by Nancy McConeghy.)

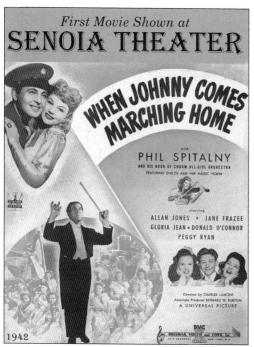

First Movie Shown at

SENOIA THEATER

Frank Hollberg recalls seeing the first movie shown in Senoia, *When Johnny Comes Marching Home*, with his father. He chuckled, relating the fact that the movie broke nine times during that first showing. Hollberg and his buddy Jim Baggarly Jr. regularly saw westerns there and said that "you could watch a movie and get a Coke and a bag of popcorn for a quarter." (Courtesy of Carla (Cook) Smith.)

Props inside Riverwood Studios include the bicycle used in *Mary Poppins* and the horse Tom Cruise rode in *The Last Samurai*. Joe Lombardi (Academy Award winner for special effects) ran the special effects department for Desilu Studios (*I Love Lucy*, *Star Trek*, etc.). He and his son Paul were looking for land for a studio when Paul met someone on the set of *Hamburger Hill* in the Philippines who sold him 120 acres in Senoia. (Photograph by Carla (Cook) Smith.)

Sue (Adams) McDaniel stands on the front porch of her 1908 home in Senoia with *Fried Green Tomatoes* actor Richard Riehle, who played Reverend Scroggins in the 1991 film. The other actors and film crew are unidentified. (Photograph by Barbara (McDaniel) Ray.)

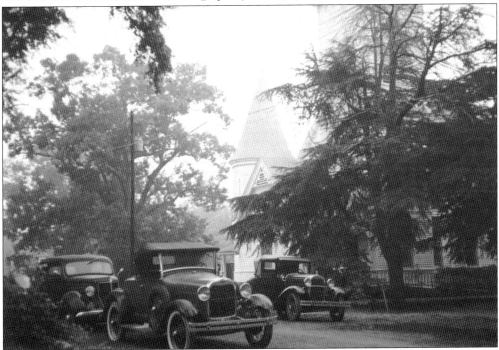

Antique cars are parked on Bridge Street during filming for *Fried Green Tomatoes*. Senoia United Methodist Church is shown in the background. (Photograph by Barbara (McDaniel) Ray.)

Patty Duke (center, with hat) stands on the set of *A Christmas Memory*, filmed for Hallmark television in 1997 and based on a true story by Truman Capote. The crew filmed at the residence of Jack and Ann Merrick on the corner of Seavy and Pylant Streets. Tyler Perry's *Meet the Browns* was also filmed here. Production crews appreciate filming at a corner location for the ease of moving equipment to cover different angles. (Courtesy of Betty (Cookman) Armstrong.)

Chris O'Donnell starred as Buddy Threadgood in *Fried Green Tomatoes* and planned to attend law school after filming. In this photograph, Sue McDaniel tells the young man he is too handsome and talented not to pursue acting as a full-time career. McDaniel liked to think her advice made a difference for the handsome, well-mannered young man she met at her home in the summer of 1991. Louise Atkinson stands to the right of her. (Courtesy of Barbara (McDaniel) Ray.)

Beth Hutchinson Tripp (left) and Jane Hutchinson (center) stand with Mary Stuart Masterson (Idgie Threadgood in *Fried Green Tomatoes*). Hutchinson recalls Lois Smith, who played Idgie's mother, practicing the line, "Ruth, you remember Idgie," many times at Sue McDaniel's house. Hutchinson also met John Travolta and Kelly Preston when he visited the set of *Broken Bridges* to see Kelly on their wedding anniversary. Burt Reynolds, who starred with Kelly in *Broken Bridges*, was happy to be photographed with Gail's Antiques' owner Gail Downs, as she greatly resembles Dinah Shore, who Reynolds dated. (Courtesy of Jane (Hutchinson) Arnold.)

Actor Gregory Hines stands with Senoia city clerk Betty Cookman and Mayor Lester Mann in front of Senoia United Methodist Church. Hines was in Senoia for the 1991 filming of *White Lie*, in which he starred. (Courtesy of Betty (Cookman) Armstrong.)

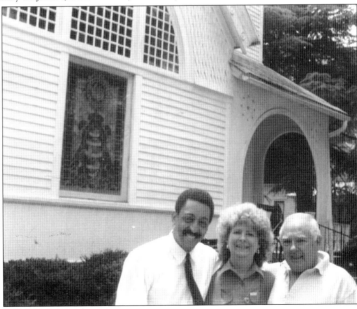

DISCOVER THOUSANDS OF LOCAL HISTORY BOOKS FEATURING MILLIONS OF VINTAGE IMAGES

Arcadia Publishing, the leading local history publisher in the United States, is committed to making history accessible and meaningful through publishing books that celebrate and preserve the heritage of America's people and places.

Find more books like this at
www.arcadiapublishing.com

Search for your hometown history, your old stomping grounds, and even your favorite sports team.